William Watts (*c.* 1717–73)
of Upper Thames St, London

...Constable m. Ann Watts
...1816) (1748–1815)

Charles Bicknell m. (ii) Maria Elizabeth Rhudde
(1751–1828) (1761–1815)

Golding
(1774–1838)

Mary Abram
(1781–1865) (1783–1862)

and four other children
of this marriage

JOHN m. MARIA ELIZABETH
CONSTABLE BICKNELL
(1776–1837) (1788–1828)

Isabel Emily Alfred Abram Lionell Bicknell
(1822–88) (1825–39) (1826–53) (1828–87)

Charles Eustace Sybil Armine

Constable Portraits

THE PAINTER & HIS CIRCLE

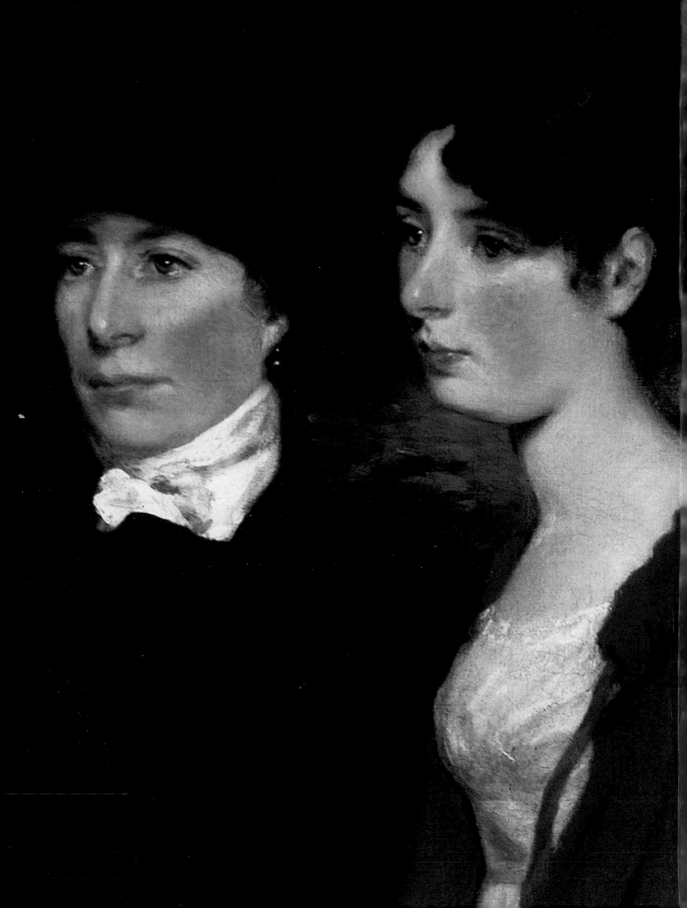

Constable Portraits

THE PAINTER & HIS CIRCLE

Martin Gayford and Anne Lyles

NATIONAL PORTRAIT GALLERY, LONDON

Published in Great Britain by National Portrait Gallery Publications,
National Portrait Gallery, St Martin's Place, London WC2H 0HE

Published to accompany the exhibition
Constable Portraits: The Painter and His Circle
held at the National Portrait Gallery, London,
from 5 March to 14 June 2009, and at
Compton Verney, Warwickshire, from
27 June to 6 September 2009.

For a complete catalogue of current publications,
please write to the National Portrait Gallery at the
address above, or visit our website at
www.npg.org.uk/publications

ISBN 13: 978 1 85514 398 2

A catalogue record for this book is available
from the British Library.

PUBLISHING MANAGER Celia Joicey
PROJECT EDITOR Susie Foster
ASSISTANT EDITOR Claudia Bloch
COPY EDITOR Linda Schofield
PRODUCTION Ruth Müller-Wirth
DESIGN Philip Lewis

Printed and bound in China

Front cover (detail) and plate 24: *Mary Freer*, 1809
Yale Center for British Art, Paul Mellon Collection
Back cover and plate 12: *A Girl in a Red Cloak* (*Mary Constable*), c.1809–14
Private Collection
Frontispiece (detail) and plate 9: *Ann and Mary Constable*, c.1814
Trustees of the Portsmouth Estates

The National Portrait Gallery's Spring Season 2009 is
sponsored by Herbert Smith LLP

Contents

Sponsor's Foreword

British Land is delighted to be the sole sponsor of the exhibition *Constable Portraits: The Painter and His Circle* organized by the National Portrait Gallery.

This fascinating exhibition explores the portraiture of one of the best loved and most talented of British artists, and offers a wonderful association for British Land. The portraits reveal much about John Constable's life: about his friendships and family connections, and about those he admired. The landscapes displayed with the portraits reinforce the sense that this was a man for whom place and people were intertwined.

We hope this beautiful and remarkable exhibition will be enjoyed by the many who visit it, and by those who read this catalogue.

CHRIS GIBSON-SMITH
CHAIRMAN
THE BRITISH LAND COMPANY PLC

Director's Foreword

John Constable is one of the greatest painters of the English landscape, but this should not limit appreciation of the full range of his exceptional talent. Along with his contemporary J.M.W. Turner, he changed the terms by which the landscape might be depicted, producing innovative, lyrical evocations of land, coast and sky. The great retrospective exhibition of October 2002 in Paris – co-curated by Lucian Freud and William Feaver – not only emphasized the role that the human figure plays in Constable's landscapes, but also demonstrated that his portraits are a complementary, but overlooked, part of his œuvre.

Constable may have had limited enthusiasm for commissioned portrait work, but this did not prevent his eye and hand being brought to bear with telling acuity. The most intense portraits appear to be those in which there is a sympathetic relationship to the sitter, none more so than with his immediate family and friends. These are not portraits of honour but portraits of affection: tender depictions, which at times look wonderfully modern, whatever the conventions of dress and pose. In the same way that Constable's sky paintings demonstrate a close focus on weather and cloud patterns, so his studies of people encourage an intimate view of an individual and something of their relationship with the artist.

The idea for this exhibition and book was proposed by art critic and writer Martin Gayford, and developed with Anne Lyles, Tate curator and an acknowledged scholar on Constable. I am grateful for their creative and determined focus on this neglected body of work. Close support has been provided by Sarah Tinsley, Head of Exhibitions and Collections Management, Sophie Clark, Exhibitions Manager and Susie Foster, Project Editor, and I want to thank them for the thoughtful and efficient way in which they have brought this project to fruition. My thanks also go to Pim Baxter, Claudia Bloch, Andrea Easey, Denise Ellitson, Neil Evans, Michelle Greaves, Celia Joicey, Ruth Müller-Wirth, Jude Simmons, Liz Smith and Lottie Wake, as well as other National Portrait Gallery staff, for all their hard work on the exhibition and the catalogue.

I am delighted that the exhibition will also be seen at Compton Verney, with whom we have enjoyed a close relationship, and my thanks go to Kathleen Soriano, Director, and Antonia Harrison, Curator, for their enthusiasm for the project.

Finally I should like to thank the lenders, both private owners and curators of public collections, who have agreed to part with precious works to allow them to be seen in London and Warwickshire. I owe many thanks for their trust and enthusiasm.

SANDY NAIRNE
DIRECTOR

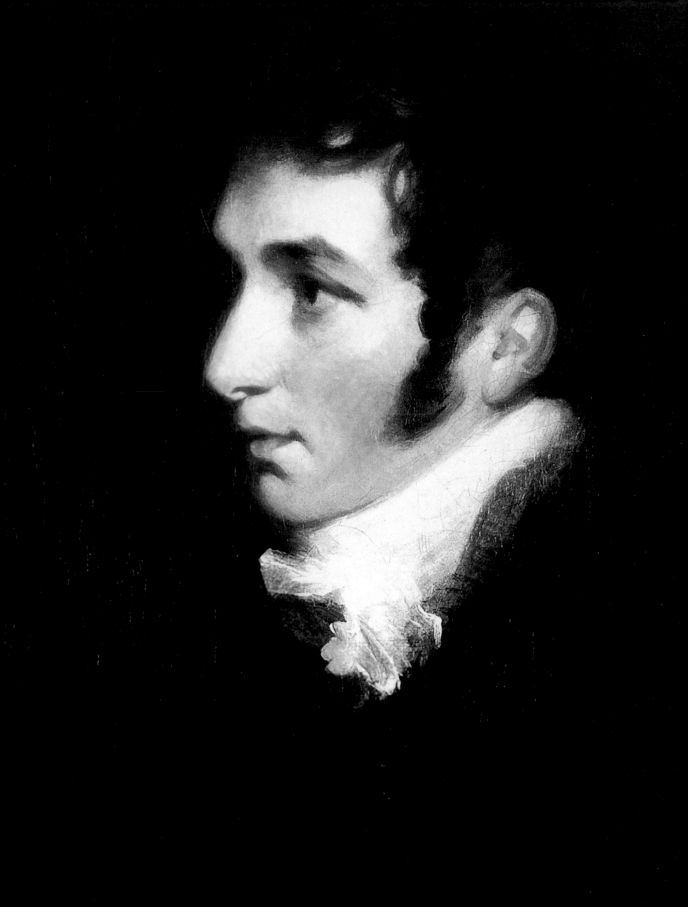

Constable:
The Natural Portrait Painter

MARTIN GAYFORD

This is the first publication devoted to John Constable's pictures of people. In itself that is a remarkable fact, considering Constable painted a sizeable quantity of portraits – perhaps around 100, taking lost works into account – and also that he is one of the most celebrated and popular artists that Britain has produced. Moreover, a number of his most important works of this kind – *Revd Dr John Wingfield* (plate 33), *Dr Herbert Evans* (plate 44) and *William Lambert JP* (plate 36), for example – have never been seen in public before. What is the reason for this neglect?

There are two common reactions when Constable's portraits are mentioned. The first is to say, 'Oh, I didn't know he painted any'. The second is to respond, 'But they aren't very good, are they?'. Together, ignorance and prejudice have consigned these pictures to the margin. They have been overlooked because there has been a received opinion that they are inferior, and because they have not often been seen that view has not been tested. This book and exhibition aim to do both: to look at them more closely and ponder the justice of their conventional dismissal.

The bad press that Constable's portraits have received goes back to the fountain head of all writing on the man and his art: *Memoirs of the Life of John Constable, Esq., R.A., Composed Chiefly of His Letters* (1843) by C.R. Leslie. This wonderful book – one of the most engaging ever written about an artist – was published by a close friend only six years after Constable's death. It quotes copiously, as the subtitle suggests, from the painter's own words. Consequently, for a century and a half, it has set the tone for discussion of Constable and his art.

Leslie did not have very much to say about his subject's portraiture, but what he did write was not encouraging. It comes early in the book, near the beginning of the second chapter:

Plate 8 (detail)

Constable's father and mother wished him to apply himself to portrait painting, but he had not the happiness, like Gainsborough, to combine landscape and portrait in equal perfection. He painted the latter indeed, occasionally, all his life, but with very unequal success; and his best works of this kind, though always agreeable in colour and breadth, were surpassed, in more common qualities, by men far inferior to him in genius.[1]

Since then, various Constable scholars have explicitly or implicitly demurred from this consensus. A number of portraits were included in the great Tate Gallery Constable exhibition of 1976 (organized by Leslie Parris, Ian Fleming-Williams and Conal Shields). Several are singled out for handsome full-page colour illustration in Graham Reynolds's masterly two-part, four-volume catalogue raisonné of the artist's work.[2] But the most thought-provoking rebuttal of the Leslie view came in 2002, when the British Council arranged an exhibition of Constable's works in Paris, selected by Lucian Freud and William Feaver.

Again, a number of portraits were on show, and made an impression on visitors. William Feaver, in a conversation with Freud (printed in the French catalogue and separately in English), observed, 'As long as I've known you, you've talked about Constable's portraits, which tend to be overlooked, just because they aren't landscapes'. To this Freud replied by saying, 'I've always thought that it was completely loopy for people to go on about portrait painters, English portrait painters, and not to have Constable among them.'

'There isn't', he continued in response to another question by Feaver,

a good painter of 'subjects' of one subject rather than any other. I mean, as a game you can say, perhaps, Gwen John was the best painter of cats (as she is), but with really good painters all their work is really good. You can't say 'this is a marvellous painter but don't look at the portraits'.[3]

Here was a rebuttal of the Leslie line, and it came from somebody in an uncommonly good position to offer an opinion: a great contemporary painter who is at once a passionate advocate of Constable's work and the creator of an œuvre full of remarkable portraits. Freud was saying that Constable's portraits could not be severed from the rest of his work, and that they deserved careful attention. This is the starting point for this book.

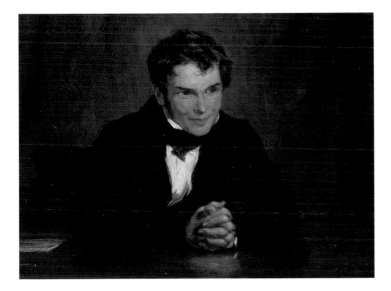

Charles Robert Leslie
(1794–1859)
John Partridge, 1836
Oil on millboard
200 × 254mm (7⅞ × 10")
National Portrait Gallery, London
(NPG 4232)

It is worth pausing for a moment to wonder why Leslie, who loved
both Constable and his work, should have written about the portraits
as he did. Charles Robert Leslie was eighteen years Constable's junior.
Born in England of American parents, he was educated in the USA,
but returned to Britain in 1811 at the age of seventeen to study at
the Royal Academy Schools. It was not until some years afterwards
that he came to know the much older Constable. He had this to say
himself of the development of their friendship:

> I had been for some time what is called *acquainted* with Constable,
> but it was only by degrees and in the course of years that I became
> really acquainted either with the man, or his true value as an artist.
> My taste was very faulty and long in forming; and of landscape,
> which I had never studied, I really knew nothing, or worse than
> nothing, for I admired, as poetical, styles which I now see to be
> mannered, conventional, or extravagant. But the more I knew of
> Constable, the more I regretted that I had not known him at the
> commencement of my studies.[4]

The two men were on good terms by the mid 1820s. The first surviving
letter from Constable to Leslie dates from 1 September 1826, and
their friendship was close for the final decade of Constable's life; after
his sudden death in 1837, Leslie did much to protect the interests of

Constable's orphaned children and establish his reputation. From this it emerges that Leslie would have had little chance to see many of the pictures in this book, all but a couple of which date from before 1826 – and the great bulk from before 1819 when Constable and Leslie probably first had contact with each other.[5] Of all Constable's portraits, only *Revd John Fisher* (plate 29) was publicly exhibited in London during his lifetime (at the Royal Academy of Arts in 1817).

Furthermore – and understandably enough – what Leslie revered in Constable's work was his approach to landscape. On the other hand, Leslie himself was a successful portrait painter – far more so than Constable ever was (his small picture of Constable is included in this book; see plate 47). He went on to paint members of the royal family and other important sitters. Portraiture, therefore, was precisely the area in which Leslie was likely to have decided ideas of his own, and was least primed to accept Constable's less conventional efforts of that kind. In any case, he had exceptional access to a source prone to talk down Constable's portraiture.

That is, Constable himself. Leslie spent many hours talking to him in life, and subsequently went through his voluminous correspondence (the basis of his book). And there is no doubt that Constable grumbled a great deal from time to time about having to paint pictures of people. For example, here is his reaction to a proposed commission from John Mirehouse, a lawyer who had married one of the daughters of John Fisher, Bishop of Salisbury. Constable dined with the Mirehouses in the spring of 1826, then wrote an account of the occasion to his friend, the Bishop's nephew, Archdeacon Fisher: 'Mirehouse threatens me with having to paint his portrait – Angels & ministers of grace defend me. He was hospitable – but there is a coarseness of manner about him that is intolerable – of his professional powers I hope I shall always remain in ignorance.'[6] It is not clear whether Constable managed to get out of performing this unwelcome task, but subsequently he was forced to paint the lawyer's father. 'I laboured hard', he wrote to Archdeacon Fisher in August 1827, 'on a portrait of Mirehouse's father – it is detestable enough of course – still he expressed himself satisfied – but he has left it on my hands unpaid for. I shudder to think that a name so dear to me [Fisher] should have merged into his.'[7] A painting of one of the Mirehouses still exists; and, as one might expect, is one of Constable's least appealing.

Complaints about having to do portraits were so common amongst Georgian artists as almost to be a professional cliché. Even those who

made fortunes out of portraiture sighed and protested about having to do so. 'I begin to be really uneasy at finding myself so harnessed and shackled to this dry mill-horse business', wrote none other than Sir Thomas Lawrence (1769–1830), the greatest and most successful portrait specialist in Constable's professional lifetime.[8] Thomas Gainsborough (1727–88) famously considered his main source of income to be 'picking pockets in the portrait way' – while his heart, like Constable's, belonged to landscape painting.

Non portrait-specialists were yet more scathing. Benjamin Robert Haydon (1786–1846) – briefly Constable's friend, before they fell out – remarked in 1817 that, 'Portraiture is always independent of art and has little or nothing to do with it. It is one of the staple manufactures of the empire. Wherever the British settle, wherever they colonise, they carry and will ever carry trial by jury, horseracing and portrait painting.'[9] For aspiring history painters such as Haydon, portraiture ranked low in the hierarchy of art. It was not a liberal art, and thus fit for a gentleman. To paint portraits was to be but what the influential early eighteenth-century critic the 3rd Earl of Shaftesbury termed a 'trading artist'. Then, there was the sheer mechanical drudgery that might be involved in that business. Allan Ramsay (1713–84), the King's Principal Painter from 1767 to 1784, once went abroad and left his pupil Philip Reinagle (1748–1833) – father of Constable's friend from his youth, Ramsay Richard Reinagle (1775–1862) – to finish fifty identical images of George III and Queen Charlotte. Subsequently, the elder Reinagle could never think of portraiture 'without a sort of horror'.[10]

Such attitudes were in the intellectual air that Constable breathed. But in addition he had individual quirks that made him especially unsuited to the trade of 'phiz-monger', as portrait painters were some-times rudely dubbed. Foremost of these traits was that Constable was constitutionally averse to painting what he did not actually *want* to paint. In his *Autobiographical Recollections*, Leslie summed up the character of his friend:

> He was opposed to all cant in art, to all that is merely specious
> and fashionable, and to all that is false in taste. He followed, and
> for his future fame he was right in following, his own feelings in
> the choice of subject and the mode of treatment. With great
> appearance of docility, he was an uncontrollable man. He said of
> himself, 'If I were bound with chains I should break them, and
> with a single hair round me I should feel uncomfortable.'[11]

This is one of the aspects of Constable that makes him fundamentally a modern artist: he chose what to paint and how to paint on inner impulse – like Picasso, Cézanne or Freud – and not at all like a jobbing phiz-monger. Or, to be more precise, if he could, he chose what to do on the basis of an inner urge. On various occasions, however, either for financial reasons or otherwise, he was unable to get out of executing a commission proposed by someone else. These he referred to as 'jobs'.

So, for example, in January 1825 he found himself at Woodman-stone in Surrey, painting a group portrait of the grandchildren of William Lambert JP. He could not easily evade this task, as Lambert was an old friend of his father-in-law's. 'You may suppose', Constable confided in Archdeacon Fisher, 'I left home most unwillingly to execute this job, but it is my wife's connection and I thought it prudent to put a good face on it.'[12]

Often, when Constable mentions a 'job' he means a portrait – because unwelcome commissions most often took the form of depicting a person – but they might be landscapes, or even such oddball ideas as the sign for the Mermaid Inn, Solihull, which Henry Greswold Lewis asked Constable to design.[13] In some cases, such as the 'job' that Constable executed for Sir Thomas Neave, father of Sir Richard Digby Neave (plate 37), it is not clear whether a portrait is meant or some landscape 'job', such as a topographical study of Sir Thomas's country seat, Dagham Park, Essex. Of course, other commissions, such as the views of Salisbury ordered by the Fisher family, were so congenial as scarcely to count as 'jobs' at all.

There were, however, aspects of portrait jobbing from which Constable was bound to flinch: the element of flattery and what is known in the twenty-first century as schmoozing that was required of the painter with a good portrait practice. These were similar to the social skills required by a lawyer, doctor or dentist ministering to high society. Indeed George Vertue (1684–1756), the early eighteenth-century engraver and antiquary, actually made the last of those comparisons, likening a portrait painter to 'a Tooth drawer who chatters to gain your favour and patience while he is doing a business of necessity'. Portraitists, thought Vertue, require 'an affable and obliging Temper, with a share of pleasant wit'.[14] These requirements grated even on those who were able to supply them. Gainsborough muttered that gentlemen 'have but one part worth looking at, and that is their purse'.[15]

Constable had a temperament very different from that needed by a portraitist. He was a private person. According to Leslie, 'Constable did not have a large circle of friends; but his friends, like those who admired his pictures, compensated for their fewness by their sincerity and warmth.' Furthermore, though an eloquent and witty man – as his letters offer ample demonstration – Constable was not cut out for schmoozing. 'He could not conceal his opinions of others', Leslie recalled, 'and what he said had too much point not to be repeated.'[16] It emerges from his comments on Mirehouse that he did not wish to portray people he found uncongenial (just, by the way, like Freud). Try as he might, Constable would never have been able to follow Lawrence and shackle himself to the 'dry mill-horse business' of painting aristocrats, politicians, generals and duchesses.

Nonetheless, Constable did paint portraits in considerable quantity. All the considerations above merely underline that he was a unique kind of portrait painter – just as, indeed, he was a unique kind of landscape painter. His portraits are as much private – to do with his inner circle, his friends and his family – as they are commissions from strangers. Very few were in fact commissioned by customers who were not at least friends of friends. If some were tedious jobs, others meant a great deal to him.

Famously, Constable once observed that 'painting is but another word for feeling'[17] – an attitude completely unsuited to an artist following the trade of jobbing portraitist. On the other hand, it led him to invest great significance in the pictures of people for whom he did feel. His emotions before the portrait of his wife-to-be, Maria Bicknell (1788–1828), were intense. This picture was painted in early July 1816, at the very point at which Constable resolved to marry her without further delay (plate 27). He then took it with him to East Bergholt, where it became a substitute for Maria herself.

'I am sitting before your portrait,' he wrote on 28 July, 'which when I took off the paper, is so extremely like that I can hardly help going up to it. I never had an idea before of the real pleasure that a portrait could offer.'[18] Like the mythical Greek sculptor, Pygmalion, he seemed to imagine that his creation had become a living being. The sight of the portrait calmed his spirit 'under all trouble', and was placed next to his bed so it was the last thing he saw at night and the first on waking in the morning. On 1 August, the day of the annual village fair, Constable took the picture on a visit to Mrs Godfrey – wife of the squire and a long-standing ally of the

painter who was too ill at the time to venture out herself. 'She wants to see your portrait', he told Maria, '& as she cannot come out I have promised to take it to her, so that *we* shall have a walk in the fair together, which is an honor that perhaps you did not expect.'[19]

Portraiture, like letter writing, played an important part in the romance between Constable and Maria Bicknell because the two lovers were frequently parted for long periods. Many of their tender conversations and tiffs took place on paper, and they gazed not on each other but on painted images. In January 1812, Constable had presented Maria with a self-portrait – now lost – as he appeared at the lowest point in their affair.

The previous year her parents had sent her to stay with her half-sister Sarah Skey, in Worcestershire, in part to keep her away from her unsuitable suitor, an apparently unsuccessful painter. During this period, when his love for Maria seemed doomed, Constable sank into a state of depression that alarmed his family.

Late in 1811, their relationship was re-established. In the New Year, Maria briefly returned to her parents' house in London, but found the situation – with Constable constantly pressing his suit, which was opposed by her family – too fraught. 'It was not without a severe struggle over my feelings', she wrote on 20 February, that she resolved to leave town but every hour showed her the necessity of doing so. In London her health and peace of mind 'would be gradually undermined'. On the other hand, she went on, 'At Spring Grove [in Worcestershire] I shall remain quiet for some months. I shall hear from you, I shall think of you, and you know I am even *to look at you*.' The image of himself Constable gave her seems to have shown the painter haggard and lovelorn. Later, Maria observed that 'the portrait you gave me looks pale … that is the only fault I find with it.'[20]

Two decades later, in 1835, when faced with parting from his second son, Charles Golding (1821–79), who had decided to go to sea as a midshipman, his response was to paint a portrait of the teenager. Constable, by that time a widowed single parent, was understandably anxious about the prospect of this fourteen-year-old facing the dangers of a sailor's life in a wooden merchant ship. 'Poor dear boy', he wrote, 'I try to joke, but my heart is broken'. He felt 'bereaved' of 'this delight-fully clever boy'. His response to this worrying situation was to paint Charles Golding before he set sail (plate 46) – and Constable was pleased with the result, 'In the midst of all my perplexities I have made a good portrait'.[21]

If these very personal pictures came out of separation from his loved ones, the various pictures he made of Maria and their young family in the years between 1817 and 1822 came out of pure contentment. Constable described those years as 'the 5 happiest & most interesting years of my life',[22] and that feeling glows out of such pictures as *Maria Constable with Two of Her Children* (plate 38) or the recently discovered *Child in a Garden, Probably the Young John Charles Constable or Charles Golding Constable* (plate 43). Others in this group show a child, probably Charles Golding, playing with a toy cart in the garden and – almost certainly – Maria in the garden holding a parasol to protect her from the heat (see p.27). Such sketches come as close as anything does in the history of art to the photographic snaps of a proud contemporary father.

Obviously, not all Constable's portraits and pictures of people were filled with such strong emotion. At times, circumstances forced him to carry out 'jobs' – with more or less conviction. Some of these turned out well, others less so. But Constable's success and failure as a portrait painter is not really comprehensible without taking a closer look at his life.

A Boy with a Toy Cart
John Constable, c.1821–3
Oil on paper
196 x 241mm (7¾ × 9½")
Private Collection

John Constable was born on 11 June 1776, the second son of Golding Constable (1739–1816) of East Bergholt, Suffolk, and his wife Ann, née Watts (1748–1815). The social and economic circumstances of his background had a great effect on his subsequent career. The Constables of East Bergholt were prosperous and upwardly mobile. Their forebears had been farmers in the region of south-east Suffolk and north Essex for generations. Constable's uncle, Abram (1701–64), had done well as a corn merchant in London and bought the watermill at Flatford, where he lived in later life in the millhouse.

Childless, Abram left this business to a favoured nephew, Golding, who quite rapidly built it up. Golding constructed and operated a seagoing merchant ship, the *Telegraph*. He also owned a fleet of barges that plied the River Stour carrying flour downriver to the port of Mistley, Essex – from whence it could be transported to London on the *Telegraph*. The barges carried other goods, particularly coal, back up the Stour towards Sudbury.

Golding Constable was a substantial local figure. He built a new home, East Bergholt House, in 1774, which – with the squire's Old Hall, the Rectory and the Roberts's West Lodge – was one of the

finest mansions in the village (see plate 5). This status symbol of a building was the place where John Constable was born.

Constable's antecedents were crucially different from those of Gainsborough, who was his predecessor as master of the East Anglian landscape. The Gainsboroughs came from Sudbury, just upriver at the end of the journey for Golding Constable's barges. The Gainsboroughs too were upwardly mobile. The painter's uncle was a successful businessman but his father, John Gainsborough, failed in trade, went bankrupt and ended up as the Sudbury postmaster. When young Thomas showed precocious talent as a painter, there was no question as to what he should do. He was sent to London at the age of thirteen to learn his art.

John Constable's career – as projected by his hopeful parents – was not like this at all. He was sent to Dedham Grammar School, an excellent institution that produced other distinguished ex-pupils. His father's first hope was that John would follow him into the family grain and transportation business since the eldest of the Constable boys, named Golding after his father, was – because of an unspecified mental incapacity or quirk of personality – unsuited for business. When, in turn, John appeared also unfitted for trade, his parents' next idea was that he might go into the Church.

This – for an unbusinesslike but clever youth from a prosperous family – seemed an obvious occupation. Many years later the Revd Dr Durand Rhudde, the Rector of East Bergholt and grandfather of Maria Bicknell, was still saying that he would withdraw his objection to her marriage to Constable if the latter would give up the unsuitable career of painting and become instead a clergyman.

So Constable's choice of path was anything but inevitable. It derived from an inner urge – hard to explain in a boy who came from a family with no artistic connections and who had never seen a good painting until the collector and painter Sir George Beaumont (1753–1827) showed him a small work by Claude Lorrain (*c.*1600–82) in 1795, when he was nineteen. Constable became a painter despite the vehement opposition of his father – just as Cézanne, Matisse and others later did. One of the watersheds between the artists of the modern era and those who came before, is that the former essentially worked for themselves – rather than for patrons or customers. That was Constable's attitude from the start and is one of the qualities that marks him as a modern artist. As Leslie put it, he was an 'uncontrollable' man.

When it became apparent that Constable's younger brother Abram (1783–1862) was well fitted by character and talents to run the family enterprise, John was freed to begin his training as a painter at the Royal Academy Schools. This, however, was not until the spring of 1799, when Constable was approaching twenty-three years old. It was a late age to begin his training – Turner had been in his early teens when he entered the Academy Schools.

He was funded by an allowance from his father. The older Golding Constable decided to tolerate his son's whim – partly out of kindness, partly perhaps because of John's quiet uncontrollability – but let it be known that he thought the ambition to become a painter was quixotic. Indeed – with a verbal muddle worthy of Mrs Malaprop – Golding Constable was in the habit of remarking, 'Here comes Don Quixote with his Man Friday', when he spied Constable returning from a sketching trip with his amateur artist friend the village glazier and plumber, John Dunthorne.[23]

His more serious view was that his son was wasting his time. On 29 June 1801, the painter and diarist Joseph Farington (1747–1821) noted in his *Diary*, 'Constable called. – His Father has consented to his practising in order to profess Painting, but he thinks he is pursuing a shadow. Wishes to see him employed.' Mr Constable's view was again jotted down by Farington nine years later, on 28 June 1810. It was expressed in almost identical words, with the addition, 'what employment He has He owes to the kindness of friends'.[24] Constable's progress as a painter was slow. He exhibited at the annual Royal Academy exhibition regularly from 1802, but without attracting much attention or generating sales. His income continued to come mainly from his father's allowance. He did not even put his name forward for election as an Associate of the Royal Academy until 1810, when he was thirty-four (for comparison, his precocious contemporary Turner attained that position at twenty-three).

Under these circumstances, it was clearly difficult for Constable to resist suggestions coming from his parents. To them, one of the most obvious ways in which he could gain 'employment' in his chosen career was by painting the portraits of their friends and acquaintances in the locality. Leslie reported, doubtless based on the artist's own recollection, that Constable's parents wished him to apply himself to portrait painting.

This must have been the reason he found himself painting the first major portrait commission to survive, *The Bridges Family* of 1804.

The Bridges Family
John Constable, 1804
Oil on canvas
1359 × 1838mm (53½ × 72⅜")
Tate

George Bridges, the father of this family, was a person of importance to Golding Constable. He was a banker and held the lease of the port of Mistley, where Golding rented a quay for his ship the *Telegraph* to dock and load. He was precisely the sort of person who would come to Constable's parents' minds as a suitable sitter – and whom they could approach and ask for a commission on their son's behalf.

The resulting painting is stiff and a little awkwardly composed. The painter stayed at the Bridges' residence, Lawford House in Essex, for several weeks while working on it. The two preliminary drawings of the daughters gathered around the harpsichord are both livelier than the actual painting in which Constable tackled the daunting task of grouping ten figures together. According to Freud, 'to paint people together' is 'one of the most difficult things of all to do'.[25] The young Constable was not up to it. The individual figures have evidently been

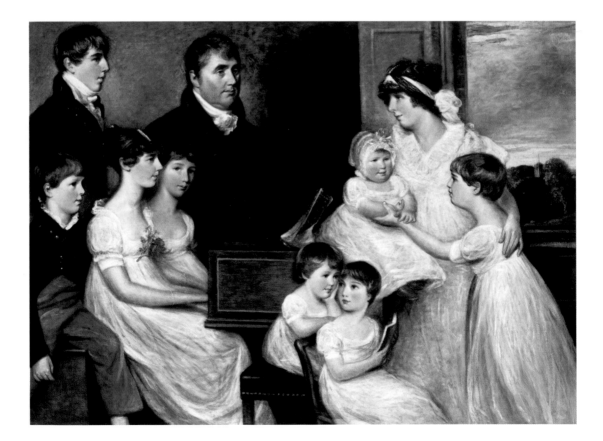

studied separately and do not appear to occupy a common space. The picture looks like what it was – an assigned 'job'.

That is not true of all Constable's early pictures of people, by any means. Two years later, in 1806, came the most aberrant year in his artistic output. In the autumn, he travelled on a painting expedition to the Lake District – his one venture out of the landscape of southern Britain. During the summer, he produced a profusion of informal sketches of people, principally during two stays with a Quaker family named Hobson at Markfield House in Tottenham and his relations the Gubbins family of Epsom.

These drawings do not look like set tasks at all (see plates 17–20). They are filled with careful observation and what looks very much like pleasure in the social scene. Constable had a sharp and humorous eye for people, as his letters and journals also reveal. His sketches of social occasions are recalled by a passage such as this, from his journal for Saturday 3 July 1824, 'Saw Mrs. Ottley, a tall beautiful and very elegant woman lying on a sopha [*sic*] elegantly dressed & reading Captain Hall's *South America*. Pink and white was her dress – she was very thin – & very round – she had flesh coloured stockings – & very beautiful legs.'[26]

The artist seemed to be enjoying himself in those summer months of 1806. It is not known how he came to know the Hobsons – this early period of his life is far less well documented than his later years – but his aunt, uncle and cousins Gubbins were certainly dear to him. Just before Christmas 1813, he described them to Maria Bicknell as 'a family, in which a good deal of my youth was spent, and who have always loved me like a son and a brother – this if you knew them you would find was saying a good deal, for they are certainly the most affectionate family in the world.'

This helps to explain the emotional tone of these beguiling little vignettes of Georgian life. It does not though clarify their purpose, or why there are so many of them. It seems that they might have been intended to help him with group portraits, and from the look of *The Bridges Family* Constable needed all the practice he could get in that area. *The Barker Children* (plate 22), from about five years later, shows that he had indeed made progress.

Constable's s friend, Sir David Wilkie (1785–1841), scored a sensational success at the Royal Academy exhibition of 1806 with a low-life conversation piece, *Village Politicians* (Private Collection). Was Constable considering following and attempting to find success

Thomasine Copping
John Constable, 1808
Oil on canvas, inscribed
'Thomasine Copping / John
Constable Pinxt / 1808' and, verso,
in a later hand, 'Thomasine Howes
of Helmingham in Suffolk painted
by John Constable in 1808'
533 × 361mm (21 × 14¼")
Private Collection

with conversation pieces, though set in a more middle-class milieu?
In 1806, Constable's character as an artist was not yet entirely set.
He experimented with the Lake District landscape, which he
eventually decided was not really 'him'.

Possibly, the same process occurred with portraiture and conversa-
tion pieces. Certainly, several of the pictures of people he painted over
the next few years do not look as if they were done against his will.
Jane Anne Mason (*Mrs James Inglis*) and *Mary Freer* (plates 14 and 24)
seem observed, if not actually *con amore*, at least with warm sympathy.
There were doubtless reasons why Constable succeeded so well with
pretty female sitters.

Constable was of an age and a temperament to take an interest
in young women. One of Constable's most beguiling pictures of a
youthful female sitter depicts Thomasine Copping, a lady's maid in
the Dysart family. She came from Helmingham in Suffolk and may
have been the daughter of a tenant farmer on Lord Dysart's estate
at Helmingham Hall, though whether her portrait was painted in
Suffolk or at the Dysart London residence is not known. Nor is it
known whether her portrait was painted on commission. The fact
that she wears a fine earring suggests her status was more elevated
than that of a housemaid plain and simple. It is nevertheless unusual
– and intriguing – to find Constable painting a member of the servant
classes. That he was aware of Thomasine's unpretentious charm is
evident in the painting.

What Constable's women – even the prettiest of them – are not,
however, is glamorous in the manner of society women painted by
Lawrence, Sir Joshua Reynolds (1723–92) or John Hoppner (1758–
1810). Constable learnt a good deal about the technical aspects
of portraiture from copying the Tollemache family portraits (see
pp.38–40), but his sitters still have the appearance that William
Feaver observed: 'They could be characters from novels by Jane
Austen or George Eliot – provincials who look as though this is
the first time they have considered sitting for a portrait.'[27]

Constable's people are – like the landscape in his oil studies –
direct, freshly observed and truthful. Michael Kitson noted that
Constable shared several characteristics with William Hogarth
(1697–1764) and Gainsborough. One was Englishness, or that 'more
broadly all three artists were part of that secondary current in British
eighteenth-century art which stressed the Anglo-Saxon rather than
the Mediterranean roots and affinities' of their culture. Another – a

more surprising observation – was that 'as painters they were largely self-taught'. 'It may be naïve to say so', Kitson continued,

> but to be self-taught as an artist before the mid-nineteenth century surely creates a bias towards realism. Such an artist may, and often does, copy other works of art (Constable was an avid and highly skilled copyist) but he does not learn the tricks of manipulating and rearranging forms by this means. His instinctive recourse is to study nature itself.[28]

In the case of portraiture, it would be more precise to say that when Constable does attempt those tricks, they fail entirely to come off. A good example is *Master Crosby* (plate 21), signed and dated 1808, in which Constable attempts an elegant posture of the kind employed with such ease by Reynolds or Lawrence. The result, for whatever reason – lack of practice, lack of conviction – is awkward and gawky. The quality of the painting lies in the marvellously lively and assured handling of the boy's face – the section, one suspects, that was painted with the sitter in front of him. This is the passage that is evidently by the same painter as the landscape sketches of this period, such as *East Bergholt House* (plate 5), in which you can almost feel the sun on the side wall of the building.

Constable's portraits do indeed have an affinity not so much with anything by his contemporaries as with works by Hogarth and the young Gainsborough of over half a century before. The link is that – as Kitson suggested – in all three cases, you get the feeling that the artist is painting precisely what he sees. There is no theatricality, no allusion to classical sculpture, no added charm or social refinement.

Constable's more successful portraits are not all of female sitters. He did well, too, with children, with whom he had a natural rapport. Leslie remarked that his fondness for them 'exceeded' that of any man he ever knew. Friendship is also an important factor in the success of his pictures of people.

With male sitters, Constable often succeeded if they belonged to the circle of his family and friends. In that case, the picture ceased to be a tiresome 'job'. Obviously, his younger brother Abram (plate 8) – a firm and reliable supporter as his letters attest – comes into this category. So too, more surprisingly perhaps, did the fussy and quirky Henry Greswold Lewis (plate 23), at least to some extent. Constable evidently complained about him, leading his mother to observe, 'I am glad to know you have received a friendly letter from Mr Lewis, tho'

he is a very eccentric character, he is a friend of value to you – and such, artists must cultivate.'[29] Lewis evidently could be very trying, but the tone of Lewis's letters – though as fussy and valetudinarian as Jane Austen's Mr Woodhouse – is also kindly. He sends game and presents of his cook's celebrated pies to the Constables, asks after their health and offers to promote Constable's cause with other patrons.

This note of friendship is perhaps – as well as the usefulness of the money he paid – the reason why Constable's professional relationship with him lasted two decades. In 1824, Constable finished the fourth repetition of his portrait of Lewis, not with complaints, but with positive satisfaction in his work. 'Got up pretty early', he noted in his journal for 13 July 1824, 'began to work on Mr Lewis's portrait which I thought was done – but I worked on it all morning and made it look beautiful.'[30]

Friendship was not only important in Constable's portraiture, but also in his life. In the early 1800s, he developed a routine of spending the winter and spring months in his London lodgings – over the years he moved around the Soho area living in Rathbone Place, Percy Street, Frith Street and Charlotte Street – but returning at intervals, particularly in summer and early autumn, to East Bergholt. His life in the metropolis was an isolated one, or at least so he found it.

He had a number of friends and relations in London, including his uncle David Pike Watts, and the connoisseur and gentleman painter Sir George Beaumont, who had taken an interest in him since adolescence. In addition, he made contacts in the art world, among them the older painters Farington and Benjamin West (1738–1820), and also some contemporaries. Nonetheless, he wrote of 'this gloom of solitude, which (however paradoxical it may seem) I find London to be.' Then he quoted the poet James Thomson, 'I am alone amidst thousands.'[31]

Clearly, he yearned for company, and company of a specific kind: not the great social world, but the smaller circle of intimate friends that he slowly accumulated. The first such friend of the heart for Constable, the younger John Fisher, nephew of Bishop Fisher, he did not get to know until 1811 and was only seldom in London. Even more than sympathetic companionship, he wanted a wife and family.

A watershed in his private life came in the last part of 1809, when he declared his love for Maria Bicknell, granddaughter of the Revd Dr Durand Rhudde – Rector of East Bergholt-cum-Brantham – and daughter of Charles Bicknell, a prominent London solicitor. Maria

had visited her grandparents on previous occasions, according to Leslie, but Constable first met her in 1800, when she was twelve. Nine years later, it seems he declared his love and this, which he later described as 'by far the most affecting event of my life', occurred while they were walking on the fields between the Constables' house and the Rectory.[32]

Little is recorded of the earlier stages of the romance, in contrast to the profusion of correspondence that came later. It seems, however, that to begin with all went well, but in time Maria's family became doggedly opposed to Constable's suit. This objection came most forcefully from Maria's grandfather, Dr Rhudde – an arrogant, irascible and wealthy man. He did not take well to this unconventional son of one of his parishioners marrying his favourite granddaughter. Her parents also seem to have felt – with reason – that an unsuccessful painter twelve years her senior was not the ideal person to support their daughter, whose health was delicate (she, and many of the Bicknell family, suffered from tuberculosis). To part Maria from Constable, she was sent to stay with her half-sister, Sarah Skey, in Worcestershire in 1811. By a series of manoeuvres – including an unheralded dash north on the mail coach to Worcestershire – Constable rekindled the relationship, but for the next five years the two of them communicated largely on paper with only intermittent, and often fraught, meetings in person.

Eventually, the death of Golding Constable in May 1816 – and John's subsequent inheritance – provided them with just sufficient income to marry. The ceremony was on 2 October 1816, following 'warm words' between Maria and her father, who was opposed to the end. The couple spent most of the autumn staying with the younger John Fisher and his new wife at Osmington, Fisher's parish in Dorset.

Their return marked the beginning of another new phase in Constable's life. His wooing of Maria had spurred him on to greater achievements as a painter, and it was during these years that his art matured. During this time, portraiture played a part in making him seem a more plausible suitor. Several commissions – especially those for more socially prominent sitters such as Bishop Fisher of Salisbury and Rear-Admiral Western of Tattingstone Park, 1813 (see p.46) – are mentioned repeatedly. Their existence was a promising sign that he might be able to make money as an artist. On the other hand, these pictures were further evidence that Constable was utterly unsuited to formal portraiture. His image of Rear-Admiral Western is an attempt at the kind of heroic full-length naval portrait of which

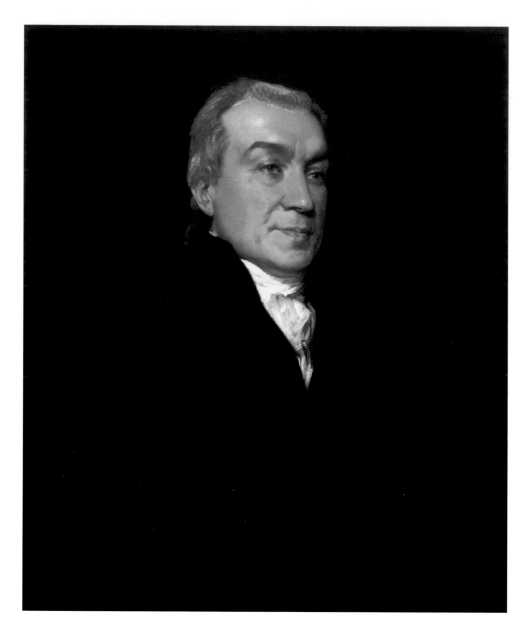

Revd Dr William Walker
(1765?–1835)
John Constable, c.1818
Oil on canvas
749 × 622mm (29½ × 24½")
Private Collection

Reynolds's *Commodore Augustus Keppel* (1753–4; National Maritime Museum) was a superb example. Constable produced instead a rather uncomfortable-looking middle-aged man who does not – or whose painter does not – know where to place his legs. Constable, though aware that this was the sort of commission he should be tackling from a professional point of view, did not approach it entirely seriously. 'I must procure', he wrote to Maria, 'a supply of the crimson, ruddy and purple tints and of the deepest dye' in order to depict the Admiral's complexion.

Now that he was married, the pressure to support his wife and – soon – a family was intense. Maria suffered a miscarriage early in 1817, but their first child – a son named John Charles – was born that December. Six more children followed over the next decade.

It was in the year after John Charles's birth – with new responsibilities and a limited income – that Constable made the greatest effort of his life to develop a practice as a portrait painter. In a short period he produced *Revd Dr John Wingfield* (plate 33), the family trio of *Mrs Tuder* (plate 34), *Mrs Edwards* (plate 35) and *Revd Dr William Walker* (see opposite), *Mrs James Pulham Snr* (plate 32), *Revd Dr James Andrew* and *Mrs James Andrew* (p.44) and – it seems – a further portrait of Bishop Fisher. These are among the finest and most accomplished portraits he ever produced.

In 1819, he exhibited his first 'six-foot' landscape, *The White Horse* (The Frick Collection, New York) – a step up in scale and ambition in his art as a landscape painter. This was bought by the younger John Fisher and was followed at long last by his election as an Associate of the Royal Academy.

In June 1817, Constable rented larger accommodation in a house on Keppel Street, near the British Museum, and there the family stayed – with summer retreats to Hampstead – until 1822. It was the period in Constable's life of greatest contentment. 'In Keppel Street', he wrote to Fisher in 1822, after they had moved, 'we wanted room and were like "bottled wasps on a southern wall" – but the 5 happiest & most interesting years of my life were passed in Keppel Street. I got my children and my fame in that house, neither of which I would exchange with any other man.'[33] These were the years of the blissful sketches of Maria and the children in the garden at Hampstead (see plate 43 and p.17) and indoors (plate 38 and p.28), perhaps at Keppel Street. This was also the era of several of his best-known works, such as *The Hay Wain*, (1821; National Gallery, London).

Mrs Constable in Her Garden
(1748–1815)
John Constable, *c.*1821–3
Oil on ?paper
280 × 225mm (11 × 8⅞")
Whereabouts unknown

**A Drive in the Nursery:
John Charles and
Maria Louisa Constable**
John Constable, *c*.1821–2
Pen and ink and watercolour
84 × 189mm (3¼ × 7½″)
Private Collection

After the mid 1820s, Constable's family life began to darken as Maria's illness became progressively worse. He was beset by anxieties about her health, the children's frequent illnesses and the struggle to make sufficient income to support them all. This affected his own mental and physical well-being. In August 1825, an enquiry from a patron, Francis Darby – son of Abraham Darby of Coalbrookdale – produced an outpouring of his inner disquiet:

> Could I divest myself of anxiety of mind I would never ail any thing. My life is a struggle between my 'social affections' and my 'love of art'. I dayly [*sic*] feel the remark of Lord Bacon's that 'single men are the best servants of the public'. I have a wife (daughter of Mr Charles Bicknell of the Admiralty) in delicate health, and five infant children. I am not happy apart from them for even a few days, or hours, and the summer months separate us too much, and disturb my quiet habits at my easil [*sic*].[34]

For the good of her health, Maria spent long periods from 1824 to 1826 in Brighton, joined from time to time by Constable.

At this stage his portraiture was largely confined to family 'connections' – he did a series of pictures of the Bicknell family, mostly now lost, and Charles Bicknell's friend William Lambert (plate 36). But the fine portrait of Sir Richard Digby Neave (plate 37) – a wealthy amateur artist, informal pupil and firm friend of the artist – was not

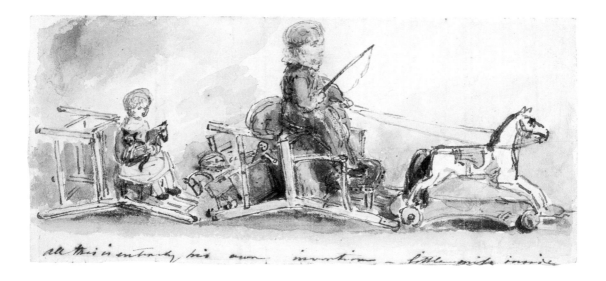

all this is entirely his own invention – little mice inside

a 'job' forced on him by family ties. If his three fine female portraits of 1818 (plates 32, 34 and 35) – Mrs Pulham, Mrs Tuder and Mrs Edwards – seem like female characters from Jane Austen and George Eliot, here is a youthful hero from a nineteenth-century novel: an Edmund Bertram or Mr Darcy.

Maria died on 23 November 1828, a few months after the birth of their seventh child, Lionel. The loss clouded the remainder of Constable's life. 'I shall never feel again as I have felt', he wrote a few days later, 'the face of the world is totally changed to me, though with God's help I shall do my next duties.'[35] Those responsibilities were most obviously the upbringing of a large family of motherless children.

During Constable's last decade he produced few portraits. The financial need to do so was much less. However, he did not entirely lose the impulse to paint people. Shortly after Maria's death, he produced a beautiful picture of Dr Herbert Evans (plate 44), who had treated her during her illness and was an emotional support to the artist in the years that followed (typically, the companion picture of Dr Evans' mother, to whom the painter was less close, is not as strong).

His last significant portrait – perhaps the final one he did – was of his beloved second son Charles Golding – Charley – on the occasion of his going to sea as a midshipman at the age of fourteen (plate 46). This plunged Constable into a turmoil of anxiety, in the midst of which he noted with something like pride, he made 'a good portrait' – like the one of Maria from 1816, an image heightened by the prospect of absence.

Contrary to Leslie's verdict, and the received opinion, Constable made a number of good, indeed remarkable, portraits. But his pictures of people were erratic, and as Freud noted, 'they aren't really as developed as the body of his work'.

'If you think', Freud observed, with Mrs Tuder, Edwards and Pulham in mind, 'these are by the same person who did the land-scapes, certainly, the way they are conceived is more primitive. You could say that Constable didn't think of them as special. Someone who'd seen Ingres' formal portraits said, "Oh, M. Ingres, I saw a nude by you", and he said, "yes, I have more than one brush".'[36]

Constable's portraits are no more than a vestigial might-have-been, a kind of painting that he never fully took on. Even if financial circumstances had forced him to do more, it seems unlikely that his temperament would have permitted him to become a successful professional portraitist. He was too prickly, too private and too honest.

The Artist's Mother
(Marie Françoise Oberson; 1769–1851)
Jean-Baptiste Camille Corot, 1835–40
Oil on canvas
408 × 330mm (16⅛ × 13")
National Gallery of Scotland

Donegal Man
Lucian Freud, 2006
Oil on canvas
559 × 457mm (22 × 18")
Private Collection

Nonetheless, though his pictures of people were done – to use Ingres' metaphor – with his 'other brush', one is aware when one looks at the best of them that they were done by a master of paint, with an observant eye and a warm heart. Constable's portraits are not obviously by the same artist as his great landscapes and oil sketches: Freud said recently that you would not guess, looking at *Master Crosby* or *Revd Dr John Wingfield,* that they were by Constable.[37] But they are painted with the same gentle but decisive strokes of the brush as his fields and skies.

They suggest a possibility that was not carried forward in Britain but in France, where Constable's landscapes were received with enthusiasm, by Géricault, Corot and Courbet. It was a way of painting people that was direct, factual and concrete. It did not reappear in London for more than a century, in the works of artists such as Sickert, and – eventually – Freud himself.

Notes

1 Leslie 1951, p.22.

2 Reynolds 1984 and 1996.

3 Feaver 2003, p.27.

4 Leslie 1860, vol.I, p.64.

5 See JCC III 1965, pp.1–7, for Leslie's friendship with Constable.

6 JCC VI 1968, pp.217–18 (letter to John Fisher, 8 April 1826).

7 Ibid., p.232 (letter to John Fisher, 26 August 1827). The Mirehouse portrait, which is probably the son, is R.26.24.

8 Shawe-Taylor 1990, p.7.

9 Ibid.

10 Ibid., p.9.

11 Leslie 1860, vol.I, p.116.

12 JCC VI 1968, p.191 (letter to John Fisher, 23 January 1825).

13 JCC VI 1968, pp.72 7 (letters from H.G. Lewis, 23 February 1828 to 13 January 1829).

14 Shawe-Taylor 1990, pp.14, 17.

15 *Gainsborough* (exh. cat., Tate Britain, London, National Gallery of Art, Washington, and Museum of Fine Arts, Boston, 2002), p.144.

16 JCC III 1968, p.7.

17 JCC VI 1968, p.78 (letter to John Fisher, 23 October 1821).

18 JCC II 1964, p.189 (letter to Maria Bicknell, 28 July 1816).

19 Ibid., p.191 (letter to Maria Bicknell, 1 August 1816).

20 Ibid., pp.59, 107 (letters from Maria Bicknell, posted 20 February 1812 and 9 June 1813).

21 JCC III 1965, p.129 (letter to C.R. Leslie, August 1835) and JCC V 1967, p.27 (letter to George Constable, 12 September 1835).

22 JCC VI 1968, p.99 (letter to John Fisher, 7 October 1822).

23 JCC II 1964, p.22.

24 Farington, *Diary*, vol.4, p.1568, and vol.10, p.3677.

25 Martin Gayford, 'Lucian Freud: Artists on Art', *Daily Telegraph*, 22 December 2001.

26 JCC II 1964, p.352 (Constable's journal, 3 July 1824), and following quotation p.114.

27 Feaver 2003, pp.27–8.

28 Kitson 1991, p.12.

29 JCC I 1962, p.59 (letter from Ann Constable, 16 March 1811).

30 JCC II 1964, p.360 (Constable's journal, 13 July 1824).

31 Ibid., p.61 (letter to Maria Bicknell, 21 March 1812).

32 Ibid., p.78 (letter to Maria Bicknell, 22 June 1816).

33 JCC VI 1968, p.99 (letter to John Fisher, 7 October 1822).

34 JCC IV 1966, p.99 (letter to Francis Darby, 24 August 1825).

35 JCC II 1964, p.451.

36 Feaver 2003, p.32.

37 Conversation with the author, 2008.

Constable's Portraiture and the British Art Scene of the Early Nineteenth Century

ANNE LYLES

In the early hours of the morning of 10 November 1812, a fire broke out at 63 Charlotte Street in London where Constable had taken lodgings only a year before.[1] His new rooms were situated above the shop of an upholsterer called Weight and it was to transpire that Constable's sister Mary, who had been staying with him earlier in the year, had confided her fears to their mother that just such an event might one day come to pass.[2] Constable acted quickly and decisively. First he saved his most treasured possessions, including his precious correspondence with Maria Bicknell (his wife-to-be), next he calmed the agitated Weights, and then he returned to rescue a portrait belonging to Lady Heathcote that he was currently copying. He subsequently rushed back through the smoke to retrieve the entire life savings belonging to Weight's servant woman.

A neighbour across the way, at 35 Charlotte Street, the painter and diarist Joseph Farington, offered to take in some of Constable's belongings and later made a brief note in his *Diary* of the recent conflagration: 'rose at quarter past 5, being alarmed by my servants of a fire having broke out at a house nearly opposite to mine ... where Constable, the landscape & Portrait Painter lodged. He brought over many of his things etc.'[3] Whilst the house was being repaired over the next few months, Constable had to juggle his affairs between a room borrowed from another neighbour that he could use as a painting room and temporary accommodation with his uncle, David Pike Watts, in nearby Portland Place. However, things could have been a lot worse. Had Constable himself perished in the fire, he would never have become an Associate – least of all, a full – Academician. His much-admired Suffolk 'six-foot' landscapes such as *The Hay Wain* would never have been painted. Instead, Constable would have been remembered as a rather minor painter of landscapes and also – it is clear from Farington's *Diary* – as a portrait painter as well.

Plate 14 (detail)

There can never be any doubt that it was landscape painting that was Constable's first and chief love. In a famous letter to the younger John Fisher in 1821, he recalled the scenes of his 'careless boyhood' on the banks of the River Stour in Suffolk which had first inspired him to become a painter, adding that he had 'often thought of pictures of them before I had ever touched a pencil [brush]'.[4] When still working for the family milling business in the 1790s, his love of landscape painting was encouraged by various friends and mentors, amongst them the artist J.T. Smith (1766–1833) from Edmonton, north of London. Smith, like Constable, also favoured landscape over portrait painting – albeit specializing in a rustic landscape of a more picturesque kind. However, the need for income impelled Smith to take on other activities such as portrait painting, though he clearly found this tiresome: '*I profiled, three quartered, full faced and buttoned up* the retired embroidered weavers, their crummy wives and tightly-laced daughters', he is recorded as saying.[5] Echoes of Smith's resentful attitude can be heard in some of Constable's own weary pronouncements about bothersome portrait commissions in subsequent years.

It was, nevertheless, something of a bonus that any painter in this period who might prefer to devote himself (or, very occasionally, herself) to landscape painting actually had the option of supplementing their living from painting portraits. For this had not always been the case. It was only from about the middle of the eighteenth century that the commissioning of portraits began to expand beyond the narrow circle of the traditional gentleman to embrace a much wider and more varied clientele.[6] For every aristocratic patron or member of the gentry who, in the second half of the eighteenth century or early years of the nineteenth century, might commission a full-length portrait from the likes of Sir Joshua Reynolds or Sir Thomas Lawrence there was now a wealth of new, middle-class customers eager to sit for their portrait as well – even if they might be content to settle for a more modest, bust-size image or to employ a less prestigious, even a local, artist. Others still – in an age before the invention of photography – might opt for a smaller format portrait in pastels, a miniature in watercolours or a 'silhouette' profile cut from paper – perhaps even a likeness taken in wax.[7] As Farington once said to an aspiring young artist, 'portraits … will always be had at from the highest to the lowest prices'. Landscape, by contrast, 'was not much encouraged' he asserted for, unlike portraiture, it did not have 'the advantage of being supported by love'.[8]

Being a landscape painter himself, Farington knew this only too well and would surely have passed on such observations to Constable. Indeed, he took the young artist under his wing when he first arrived in London in 1799 to train at the Royal Academy Schools and in the ensuing years continued to offer him valuable advice. Such insights can only have added to the pressure we know that Constable already felt from his parents to succeed in his artistic profession, having been released by them from any obligation to take over the running of the family milling business. His parents would also, presumably, have been aware of the lower status given to landscape painting in this period – especially naturalistic as opposed to imaginative or historical landscapes – when compared with portraiture or, especially, the sort of pure history painting espoused by the first President of the Royal Academy of Arts, Sir Joshua Reynolds (classical or biblical scenes or events from contemporary history). In fact, not many artists in this period made a successful living from history painting. Reynolds himself rarely practised it. However, Reynolds did create a sort of historical portrait in which the sitter would be cast in an idealized pose taken from the Old Masters or from classical sculpture and the subject invested with an allegorical meaning, thus narrowing the gap between history and portrait painting. Indeed, Reynolds created a powerful inspirational model for portraitists of the next generation, such as John Hoppner, Sir William Beechey (1753–1839), John Opie (1761–1807) and George Romney (1734–1802).

The Academy's second President, meanwhile, the American Benjamin West, managed to carve out a career as both portrait painter and history painter. By 1811, Constable's mother, Ann, who was regularly encouraging her artist son to apply himself in his profession towards 'fame and gain', had begun to regard West as a potential role model.[9] When she visited an exhibition at the British Institution in 1811 – an additional exhibiting venue in London, which showed contemporary work as well as that by Old Masters – she saw a newly unveiled painting by West, *Christ Healing the Sick* (1811), which was subsequently acquired by subscription for the vast sum of £3,000. In a letter to Constable, she compared West's picture with an altarpiece her son had painted a few years earlier for Brantham Church in Suffolk, *Christ Blessing the Children* (1805; on loan to Emmanuel College, Cambridge) finding in favour of Constable's performance. She told him that she could 'perceive no cause or just impediment that you should not in due time, with diligence & attention, be the performer of a Picture worth £3000'.[10] It is likely that

Christt Blessing the Elements
John Constable, 1810
Oil on canvas, 1175 x 940mm (46¼ × 37″)
St James's Church, Nayland

Constable's older brother, Golding, posed for the figure of Christ in the Brantham altarpiece. Certainly the latter's features closely resemble those of the Saviour as represented by Constable in his later altarpiece for Nayland Church, *Christ Blessing the Elements* (1810), and the artist's uncle David Pike Watts claimed that this Christ was a portrait of Golding Constable.

Constable's father, meanwhile, the artist told Maria in a letter of 1812, was 'always anxious to see me engaged in Portrait'.[11] Golding and Ann Constable would have known of the successful career of local Suffolk artist, Thomas Gainsborough, who had managed to make a respectable living from combining portraiture with landscape – even if most of his income had come from the former – and they may have hoped that their son could achieve a similar juggling act (Constable himself, though hugely admiring of Gainsborough's landscapes, seems never to have commented on the latter's portraits in his correspondence). They would surely also have been aware that, of all the branches of painting, it was portraiture that offered the best opportunity for social mobility. Romney and Opie, sons, respectively, of a Lancashire builder and cabinet maker, and of a Cornish carpenter, for example, had risen to great prominence in their careers as portraitists.[12] If Constable, the son of a tradesman, was ever to succeed in winning the hand of his beloved Maria, the daughter of an eminent solicitor and thus a member of the respected professions, portraiture would clearly be a much more advantageous career move than landscape painting.

The first reference to Constable's work in portraiture comes in January 1802. Writing to the elder John Dunthorne, the East Bergholt plumber and glazier who was also an amateur artist and had given the miller's son some tuition in sketching, Constable told him: 'I have done little in the painting art since I have been in town yet. A copy of a portrait and a background to an ox for Miss Linwood is all.'[13] It is perhaps not surprising to find Constable making copies of portraits in oil at this date – he also made copies after small landscape paintings by Old Masters such as Jacob van Ruisdael (*c.*1628–82) or Claude Lorrain, especially examples of the latter's work in the collection of Sir George Beaumont. Copying was a useful way to learn painting skills, for the Royal Academy at this date did not teach oil painting. Tuition at the Academy Schools revolved instead around drawing from plaster casts and, once a certain level of proficiency was reached in that activity, drawing from the living model. In the same letter, Constable told Dunthorne how much he was enjoying some lectures

he was attending on anatomy, adding that – with the exception of astronomy – 'no study is really so sublime, or goes more to carry the mind to the Divine Architect'.[14] His anatomical studies, praised by C.R. Leslie for their beauty and accuracy, no longer survive.[15] However, many of his Academy life drawings – even some painted nude studies – are still extant and are sufficiently accomplished to indicate that, with practice and opportunity, Constable could without too much difficulty translate his skills of draughtsmanship into the potentially profitable field of portraiture in oils.[16]

It was customary in this period for artists who had originally come from the regions to train in London subsequently to travel back to the area of their birth to exploit their local connections. Constable was no exception in this respect and in the first decade of the nineteenth century depended substantially on local commissions for income – whether obtained through friends, social contacts or his father's business associates. This applied both to landscape and portrait commissions, but especially to the latter.[17] We know from Farington, for example, that around 1804 Constable was busily occupied in painting portraits of local sitters. In June of that year, Farington recorded in his *Diary* that 'Constable … had of late been much employed painting portraits large as the life for which He has with a hand 3 guineas, without 2 guineas – this low price affords the farmers &c to indulge their wishes and to have their Children and relatives painted.'[18] Farington also recorded that 'Constable has a House of his own near his Fathers where He works hard and has time in the afternoons to cultivate Landscape Painting'.[19] Evidently, then, Constable would settle into a routine whereby he prioritized mornings for portrait commissions – presumably travelling to the houses of his local sitters for the purpose – and afternoons for landscape painting.

Various portraits survive from around this date, for example one of a local man, *George Elmer* (1804), and two more of Elmer's grand-children (Private Collections), which may correspond with those Constable had mentioned to Farington in 1804.[20] However, the most ambitious picture from this period is the large group portrait *The Bridges Family* (see p.20) in the Tate. George Bridges was a business associate of Constable's father, Golding. He traded in corn, grain and iron, chiefly round Mistley in Essex – taking on Elmer's son, also George, as a business partner. The handling and softness of touch in the brushwork seem to reflect the influence of Constable's old acquaintance, Daniel Gardner (*c.*1750–1805), a former pupil of

Captain Allen
(d.1832 or 1833)
John Constable, 1818
Pencil on paper
320 x 202mm (12⅝ x 8")
Private Collection

Reynolds who later specialized as a portraitist in crayons and gouache, and who had painted a portrait of the young Constable himself in 1796. Indeed, the two artists' styles at this date have sometimes been confused.[21]

Being a large-scale portrait with several figures, *The Bridges Family* would have involved Constable making decisions about appropriate groupings as well as an overall compositional arrangement. Two sketches in pencil are known that relate to the three Bridges children gathered round the harpsichord on the left of the painting.[22] It is not clear, however, whether these were made by Constable as true compositional sketches, that is to say with that section of the picture actively in mind, or whether – as seems more likely – they were executed in an impromptu moment to capture members of the family at leisure (including the eldest girl, Mary Ann, for whom Constable is said to have developed a special fondness). In the latter case, they might then have prompted ideas for the bigger picture. In general Constable did not make preliminary drawings for his portraits, least of all for portraits of individual sitters where it seems his practice was always to work directly on to canvas. This echoes the procedures of eighteenth-century portrait painters who, on the whole, were not in the habit of using preliminary drawings either.[23] Constable did, however, occasionally use pencil for making more elaborate, finished portrait studies, such as the very fine example, signed and dated 1818, of a relation, Captain Allen.

The softness and looseness of touch that characterizes the handling of *The Bridges Family* lingers in Constable's portraiture until 1806–7, being a feature of pictures of various members of the Lloyd family (plate 16), which he painted in the Lake District and Birmingham in 1806.[24] By 1807–8, however, other influences were to come into play. In 1807, Constable was given an introduction to Wilbraham Tollemache, 6th Earl of Dysart, whose family seat at Helmingham was located not far from East Bergholt to the north of Ipswich. Constable had spent time sketching in the park at Helmingham in 1800 and apparently even worked in the house at that time copying a picture.[25] The local solicitor who procured the introduction in 1807, Peter Firmin, was at pains to impress on Lord and Lady Dysart that Constable was 'an artist and Connoisseur', as if to convey the notion that his station in life was relatively superior to that of an 'artist' plain and simple (reflecting the long-held prejudice of artists as tradesmen, a perception that was now rapidly changing).[26]

Whether or not the nature of Firmin's recommendation was a factor in Lord Dysart's decision to employ the local Suffolk artist, the commission was a good one. He asked Constable to make copies of a sequence of family portraits, some of which were located at his London mansion near Hyde Park Corner in Piccadilly, others in the residences of relations such as that of Lady Louisa Manners at Ham House in Richmond close to the River Thames. Apart from the remuneration this would bring with it, such a commission – from a long-established aristocratic family in the region – would be sure to lead to further introductions and commissions for Constable, and would be guaranteed to please his parents. The biggest bonus, however, was the opportunity it brought with it for Constable to learn more about the styles and techniques of other portrait painters, such as the legendary Reynolds and his talented follower, Hoppner. In the days before public galleries, access to private collections of the quality of Lord Dysart's was invaluable. Furthermore, if copying was one of the best ways of learning, this was especially true for Constable who did not have the advantage – as most novice portraitists did, especially in the late eighteenth century – of learning his craft as an assistant in a portrait painter's studio.

Constable's first commission from Lord Dysart, in 1807, was to copy the full-length painting by Reynolds of *Anna Maria, Countess of Dysart, as Miranda in 'the Tempest'* (1807; Hon. Michael Tollemache), one of the family portraits located in his London mansion in Piccadilly.[27] Constable was a lifelong admirer of Reynolds. He knew the *Discourses* – the lectures on the theory of painting Reynolds had delivered in his capacity as President of the Royal Academy – and would gradually have become familiar with much of Reynolds's work (he attended a special day's celebratory event in connection with a commemorative exhibition of Reynolds's paintings at the British Institution in May 1813 in the presence of the Prince Regent).[28] He was later to buy Reynolds's palette at the sale of Lawrence's effects in 1830, and then donate it to the Royal Academy.[29] However, the commission to copy *Anna Maria, Countess of Dysart* is likely to have been the first occasion on which Constable was able genuinely to scrutinize Reynolds's manner and technique.

Further requests for Constable to copy family portraits came from other members of the Dysart family around 1812 – though apparently still forming part of the original commission from Lord Dysart who would presumably have picked up the bill. That year, Lady Louisa

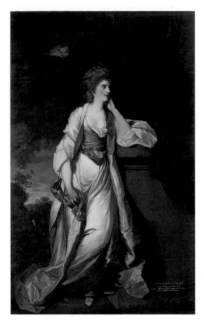

Lady Louisa Manners
(1745–1840)
John Hoppner, after an original by
Sir Joshua Reynolds, retouched
by John Constable, *c.*1812
Oil on canvas
2370 × 1450mm (93¼ × 57⅛")
Ham House, Surrey

Manners – Lord Dysart's sister, and later Countess of Dysart – asked Constable to repair and repaint a full-length portrait of herself by Hoppner after an original by Reynolds.[30] In this instance, then, Constable was being asked to copy Reynolds as interpreted through the eyes – and brush – of Hoppner.[31] The same year, Lady Louisa's eldest daughter, Katherine Sophia, Lady Heathcote, requested Constable copy her own portrait, as Hebe, this one from an original by Hoppner. Constable had actually met Hoppner by the time he was involved in this commission, having breakfasted with him at David Wilkie's house in 1808.[32] However it seems unlikely that Constable would until now have had the opportunity of studying Hoppner's technique at such close quarters. Furthermore, copying Hoppner's work in 1812 would have felt the more poignant bearing in mind that Hoppner had died, at the height of his career, only two years before.

The commission for Lady Heathcote seems to have been the more irksome of the two. Constable told Maria that 'She will not sit to me though she wants many alterations from the original – but I can have prints, drawings & miniatures, locks of hair, &c &c without end.'[33] Six weeks later, he was beginning to lose his patience, telling Maria that, though he was getting on with the pictures for Lady Heathcote, 'I shall be glad to get these disagreable [*sic*] sprawling things out of the house'.[34] He is unlikely to have anticipated the circumstances in which one of the pictures, at least, would make its exit – the Hoppner of *Lady Heathcote as Hebe* (1812; Private Collection) – which was carried at top speed down the stairs, by the artist himself, to avoid incineration in the fire that broke out in his lodgings at the end of 1812.

Constable was still involved in his work on the two Dysart portraits in June, anxious to escape to East Bergholt to enjoy the good weather and return to his landscape studies there. However, when he told Lady Louisa that he was planning to 'order [his] colors [*sic*] away', she apparently became distressed.[35] Lady Heathcote had a more uncharitable reaction, leaving 'written orders on [his] table about her portrait, the most ridiculous imaginable'.[36] At times, it seems, the ladies were in danger of forgetting Peter Firmin's remark that Constable was both artist and connoisseur.

There were, however, more than enough compensations for Constable in the work he took on for the Dysarts. Lady Louisa Manners showed great kindness to him as he continued to take on portrait commissions or other tasks in connection with her picture collection until well into the 1820s and early 1830s, inviting him to

attend her *fêtes champêtres* near the Thames at Ham House and sending him many a generous haunch of venison over the years.[37] Meanwhile, the experience of copying Reynolds and Hoppner equipped Constable with renewed confidence to try larger formats, such as the impressive group portrait of *The Barker Children* (plate 22) and the full-length of *Rear-Admiral Thomas Western* in 1813 (see p.46). Above all, Constable's portrait endeavours were by this date beginning to pay off financially. When he was ready to leave London for East Bergholt in the summer of 1813, having now finally finished the commissions for the Ladies Manners and Heathcote – as well as some other recent portrait commissions, such as that of *Revd George Bridgeman* (1813; The Weston Park Foundation) – Constable was able to tell Maria that he was 'leaving London for the only time in my life with pockets full of money. I am entirely free from debt … and I have required no assistance from my father for some time.'[38]

The charges Constable made for his portraits are generally known only if a given commission happens to be cited in his voluminous correspondence, in Farington's *Diary* or in documents still belonging to the families of the sitters. However, such references do not occur with great regularity and when they do crop up can be difficult to interpret accurately. For example, it can sometimes be unclear as to exactly what size of picture Constable is referring to in a given letter, as some of the expressions then used loosely to describe how much of the figure was represented in a portrait – head, bust, half-length, three-quarters or full-length, for example – are sometimes, but not always, the same terms used to describe specific canvas dimensions using the same names. Meanwhile, prices cited in the correspondence may have been paid in instalments and may or may not include the price of the frame (which it was often Constable's job to commission and then outsource). In addition, it might be ambiguous as to whether a fee cited refers just to one picture or else to a pair.

However, one can get a broad indication of what Constable charged for his portraits by carefully sifting the known information. Portraits were generally priced by size, the larger the more expensive. In addition, as was the case for most artists in the period, Constable's prices rose as the demand for his work increased. It has already been noted that in 1804 Constable was charging two or three guineas for a 'head' size (the difference in price depending on whether or not he also included a hand). By 1813, however, his price for what he calls a 'head' had risen to fifteen guineas – which, despite the increase, is

actually on the low side for the period bearing in mind that Lawrence, Hoppner and Beechey were then receiving at least twice this for a portrait of that size.[39] However, the context in which Constable tells Maria about his fifteen-guinea fee indicates that he was probably using the expression 'head' here quite loosely, actually referring to a specific canvas used at that time for a head and shoulders portrait confusingly known as a 'three-quarters' size, as it measured about three-quarters of a yard (three feet) in its widthways dimension prior to being fixed to a wooden stretcher.[40]

Although at this date canvases could be purchased in a roll and then cut to size as required, more often than not artists bought their canvases ready cut, stretched and primed from artists' suppliers, and Constable was no exception.[41] The suppliers issued advertisements of the canvas formats they offered, with canvas names and dimensions (cited in imperial measurements, of course). Although the sizes for any given named canvas varied a little over the years, in the early nineteenth century the most commonly used sizes were as follows (height before width):

Head size	24 × 20 inches	610 × 508mm
Bust, or head and shoulders (called 'three-quarters')	30 × 25 inches	762 × 635mm
Kit-Cat, or head and shoulders (with one or both hands)	36 × 28 inches	914 × 711mm
Half-length	50 × 40 inches	1270 × 1016mm
Whole (or full) length	94 × 58 inches	2388 × 1473mm

Constable used nearly all these sizes, but some a great deal more than others. Indeed, it is revealing to examine his portraits by size, as such an exercise sheds a great deal of light on his methods – and strengths and weaknesses – as a portrait painter, and even on the intended 'purpose' of some of the portraits.

When painting portraits in the very early years, with the exception of *The Bridges Family*, Constable generally alternated between using the three, smaller standard canvas formats, 'head', 'three-quarters' and 'Kit-Cat'. He used the 'head' quite frequently at this time, though curiously – bearing in mind that it was only intended to accommodate

a single head – almost as often for group portraits as for individual sitters, whether comprising two, three or even four figures, and usually showing them full-length. If this format works well enough for his reduced copy of the double portrait of *Ann and Mary Constable* (plate 9), it is rather less successful – and sometimes even awkward because too constricted – for groups with three or more figures, such as in the recently discovered early painting of *Ladies of the Mason Family* (plate 13). The later group portraits on this scale of *Mrs Elizabeth Lea with Her Three Children* (c.1825–6; Private Collection) sitting in their busy interior drawing room in Hampstead or *The Lambert Children* (1825; Private Collection), complete with family donkey and extensive landscape, suffer from a similar sense of confinement within too small a format.[42]

Another size that Constable favoured at the beginning of his career was the 'Kit-Cat', named after Sir Godfrey Kneller's (1646–1723) famous series of portraits on this scale of members of the Kit-Cat Club in London (National Portrait Gallery, London, and Beningbrough Hall, North Yorkshire). This was the more generous of the two 'head and shoulders' portrait formats, and more readily accommodated a sitter's hands than the smaller 'three-quarters'. We know that Constable used the 'Kit-Cat' for the first landscape he exhibited at the Royal Academy in 1802, though whether on its traditional upright format or turned on its side to form a horizontal canvas is not known – the picture is currently unidentified. What we do now know, however, is that the portrait by Constable of his mother, Ann Constable, best known in its smaller ('three-quarters') scale format at the Tate (?c.1815), also exists in an earlier, 'Kit-Cat', version by him in the Colchester Museum in which the sitter is facing in the reverse direction from the Tate picture, albeit still holding a spaniel in her lap.[43]

The recent authentication of this latter picture helps throw new light on the likely identity of the sitter shown in a male portrait, also in Colchester, traditionally identified as Constable's Dedham schoolmaster, Dr Thomas Lechmere Grimwood (plate 4). In fact, the man represented in this painting looks strikingly like Golding Constable as portrayed in the smaller ('three-quarters') version in the Tate (plate 3). The sitter is also represented on a 'Kit-Cat' size, in addition to which he faces right, thus in a complementary direction to that of Ann Constable in Colchester, to which he seems to make a pair. Furthermore, as Martin Gayford has observed, the book the man holds looks remarkably like the (still extant) Constable family Bible. The so-called

Portrait of Ann Constable, the Artist's Mother
John Constable, ?1800–07
Oil on canvas
approx 914 × 711mm (36 × 28")
Colchester and Ipswich
Museum Service

Revd Dr James Andrew
(1774–1833)
John Constable, 1818
Oil on canvas, 775 × 645mm (30½ × 25⅜")
Tate

Mrs James Andrew
John Constable, 1818
Oil on canvas, 775 × 649mm (30½ × 25½")
Tate

Grimwood picture is, then, surely a portrait of Constable's father, painted as a pair to the earlier version of the artist's mother. The fact that the two pictures shared the same provenance for many years, descending through the same branch of the Constable family, only lends weight to this new identification.[44]

The Tate versions of Constable's parents, meanwhile, may well have been painted in response to a request from a distant family relation, Harriet Savile, in 1815, for Constable to paint duplicates of his parents' portraits, taken – as the artist said in a letter written from East Bergholt in November – 'from those we have here'.[45] Miss Savile was the same relation who later commissioned a reduced-scale copy of the portrait of *Ann and Mary Constable* (plate 9), which was also first painted by Constable on a 'Kit-Cat' scale, perhaps to match the two extant portraits of his parents.[46]

After 1814, Constable seems to have abandoned the use of the 'Kit-Cat' format for portraits (though he continued to use it, turned

on its side, for landscapes). Instead, it was the so-called 'three-quarters', a size that lay between the 'head' and the 'Kit-Cat', that was destined to become by far his favourite head and shoulders format. Unlike the 'Kit-Cat', which, as we have seen, he once used for a double portrait (plate 9), Constable seems invariably to have used the 'three-quarters' size for the purpose for which it was intended, to represent a single sitter in a head and shoulders format (perhaps also adding one or two hands). He used this size with some regularity from a fairly early date, for example for his portrait of James Lloyd (plate 16), for the enchanting early portrait of his cousin Jane Mason (plate 14), and then – the next year – for portraits of his patron Henry Greswold Lewis of Malvern Hall and the latter's ward, Mary Freer (plate 24). H.G. Lewis was so pleased with his own portrait that he ordered no fewer than three replicas of it over the years on the same scale, including one (plate 23) made for a relation by marriage, Lord Bradford.[47] Lewis also commissioned from Constable a complementary portrait on the same scale of Bradford's younger brother, *Revd George Bridgeman* (1813).[48]

The 'three-quarters' was also the format that Constable was to use for some of the best portraits of his entire career, made in the period 1817–18, such as those of *Revd Dr John Wingfield* (plate 33), *Revd Dr William Walker* (see p.26), *Mrs Tuder* (plate 34), *Mrs Edwards* (plate 35) and *Revd Dr James Andrew* and *Mrs James Andrew* (opposite). Other, mainly male, portraits were painted by him on this scale in the 1820s, such as *William Lambert JP* (plate 36), *Sir Richard Digby Neave, Bt* (plate 37), *Sheffield Neave* (1825; Private Collection) and Constable's father-in-law, *Charles Bicknell* (1825; Private Collection).[49] The portrait of William Lambert, painted in 1825, is recorded as having been charged by Constable at fifty guineas.[50] However, this would represent a substantial increase in just twelve years – that is, since Constable had told Maria that he was charging fifteen guineas for what was probably a 'three-quarters' length, even if Constable was by this date an Associate Academician. The most likely explanation here is that the fifty guineas was the cost not just of the portrait of Lambert himself but also of the slightly smaller group portrait Constable painted of Lambert's three grandchildren the same year.[51]

The reasons why the 'three-quarters' format proved so ubiquitous in Constable's portraiture throughout his career can to some extent be explained by his failure to flourish on larger formats. Exactly why

he abandoned the 'Kit-Cat' format after 1814 is not clear, though it is possible it was becoming regarded as old-fashioned by that date. Interestingly, Constable never opted for the next size up, the 'half-length', or at least not for painting portraits – perhaps it would have proved too expensive for his more regular clients, yet not grand enough for those with higher aspirations and pockets to match. Meanwhile, the portrait of *Rear-Admiral Western*, the only genuine full-length that Constable painted after his own conception – that is to say, excluding copies of full-length portraits after Reynolds or Hoppner – serves to emphasize that working on the grandest of scales was never going to be Constable's forte.

The whole-length format was of necessity more demanding for a portraitist than lesser sizes, since it tested to the full their skills in draughtsmanship – and *Rear-Admiral Western* reveals Constable's evident weakness in this respect (despite the promise shown by those early anatomical drawings). The full-length also tested an artist's powers of composition, since it included ample space to be filled on the canvas (or, for the patron to request to be filled) beyond that occupied by the figure itself. Owing either to compositional needs, or to the demands of a patron wanting to project a sense of their status, portraitists working on this scale would find themselves having to include all manner of – usually inanimate – props, such as swords, walking sticks, globes, busts, curtains, carpets, architectural features such as columns, or any number of paraphernalia associated with the careers and lives of the sitter. At the times of their deaths, Hoppner's and James Northcote's (1746–1831) studios contained myriad objects of this sort.[52]

In the full-length of *Rear-Admiral Western* props are relatively minimal – his right arm is supported on an upturned anchor, whilst his left rests on the hilt of his (sheathed) sword. However, Constable had to return to Tattingstone Place in Suffolk in August 1814 to repaint Western in a new uniform, following his promotion from Captain, since the portrait had been painted the previous year – and judging from the splendour of its gilded threadwork, this would have been a time-consuming task. Constable's annoyance at missing the fine weather that summer prompted him to write to Maria that he sincerely hoped this would be 'the last portrait from my pencil [brush]'.[53] It was not, of course. However, it was his last full-length, and at least portraits on smaller formats required less attention to props and, generally, to elaborately detailed costume.

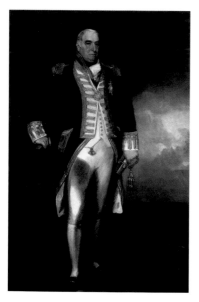

Rear-Admiral Western
(1761–1814)
John Constable, 1813
Oil on canvas
2360 × 1395mm (92⅞ × 54⅞")
Private Collection

A portraitist working on a full-length scale might also be required to include animals or children, though *The Barker Children* (plate 22) is the only example – albeit a particularly successful one – of Constable attempting to paint youngsters on a near full-length scale (*The Bridges Family* apart). Animals are occasionally included in Constable's portraits, but only in those on a format smaller than full-length. In the case of *The Lambert Children*, for example, Constable added the family donkey, a challenge Maria felt confident her husband was more than capable of handling.[54]

Of course portraits, especially full-length ones, often required fairly substantial landscape backgrounds and one would have assumed that this, of all activities, would have been something Constable might have enjoyed. However, this was far from the case. On the only occasion he took on a commission to add the landscape background to a full-length, *Eliza O'Neill* (1815; whereabouts unknown), by another portraitist, George Dawe (1781–1829), Constable did not relish the task – perhaps not surprisingly, as at one stage he was working on it for twelve and sometimes fourteen hours a day.[55] In reality, such work kept him from pursuing the only landscape he truly believed in, nature herself. Landscape was to be had on Constable's own terms and was something far too precious to be relegated to the background in a portrait. He turned down Dawe's requests to do further work of this type.[56]

The 'three-quarters' size canvas, then, was in some senses Constable's best compromise format. It also turned out to be the format most suited to his skills. It enabled him to place the sitter comfortably within the confines of the picture plane, with very little in the way of extra space for props, which are correspondingly modest in the examples he painted on this size, if actually included at all. Taking, for instance, the impressive group of seven portraits Constable painted on the 'three-quarters' scale in the period *c.*1817–18, five of the sitters – the Revds Wingfield and Walker, and the Mrs Pulham, Tuder and Andrew – are all set against simple, plain painted backgrounds. *Revd Dr James Andrew* (see p.44), by contrast, is shown with his left hand leaning on a pile of books, presumably tomes he had himself written on astronomy, nautical tables and grammar, and one can surmise that the idea to include them came from Andrew himself (indeed, he looks rather self-important compared with his more modestly represented counterparts, the other two Reverends).[57] Thanks to the plain backgrounds and lack of distracting props, most of the viewer's attention is

drawn to the expressions of the sitters and, in the cases of the Mrs Pulham, Evans and Tuder, these are especially lively and beautifully expressed. Constable then allows himself free rein to indulge in some virtuoso passages of spontaneous, creamy brushwork in their costumes, especially in the representation of sheer fabrics such as lace or muslin. These 'three-quarters' size portraits are a masterly combination of directness and understatement with touches of painterly indulgence.

Furthermore, with a canvas size designed for just head and shoulders – and with the 'three-quarters' at least (unlike the 'head'), this is how Constable used it – there was no necessity to paint the sitter's hands, which is one of the most difficult elements in any portrait. Given the opportunity, when painting on this scale Constable tends to avoid including hands at all, as in the cases of Mrs Pulham, the Revds Wingfield and Walker (see plates 32 and 33, and p.26), *William Lambert JP* (plate 36), *Charles Bicknell*, *Sir Richard Digby Neave, Bt* (plate 37) and *Sheffield Neave*. If requested to include them by a patron, as seems to have been the case with *Revd Dr James Andrew*, there was always the option of disguising one by tucking it inside a waistcoat – even if the other one had to be shown resting on the aforementioned pile of books. When Constable includes one or both hands – which happens more frequently in the case of female sitters, perhaps at their request to show off their wedding rings – they often fall dangerously close to the lower edge of the picture, as with *Mrs James Andrew* (see p.44). It is as if Constable, having not allowed adequate space for them, then had to squeeze them in.

In this context it is interesting to observe that, when painting landscapes, Constable often failed to judge the amount of space he might need at the edges of the canvas to encompass the complete view, his conception of the landscape having evolved in the course of sketching it. He would then find himself having to extend the canvas by turning out the tacking edges to increase the area of canvas for painting.[58] Partly to avoid these sorts of difficulties, around 1818 Constable developed a revolutionary new method whereby, when planning a new landscape in the studio destined to be worked up for exhibition, he would start by painting a full-scale sketch – that is to say, a complete sketch the same size as the intended, finished land-scape. Once the composition was more or less resolved, he would then begin a fresh canvas based on the same-size sketch.[59] Despite this new practice, however, Constable might still thereafter submit

for exhibition a 'finished' landscape, the composition of which he had extended either by turning out a tacking edge and painting over it, or by adding strips of extra canvas.[60]

Such options were unlikely to be viable for Constable, however, when painting a portrait. A portrait was priced by size and it might also be one of a pair – *Mrs James Andrew* was painted as a companion piece to the portrait of her husband – in which case each picture would need to end up, and be framed, the same size. Such deficiencies as the misjudged placing of a hand could, in an ideal world, perhaps have been avoided if Constable had made preliminary drawings, though – as it has been seen – this was not his custom. Nor was it Constable's habit to paint preliminary oil sketches for his portraits, on the same scale or otherwise, though there are two fascinating exceptions. He made a preliminary sketch of the portrait group of *Maria Constable with Three of Her Children* (plate 39), later worked up as the more elaborate picture with an extra child, illustrated right (now lost); and a small oil sketch when planning the composition of *The Lambert Children*, presumably owing to the complexity of the grouping and the fact that the children were likely to be restless when posing.[61] With respect to portraits at least, Constable was, then, painting for a price. Time was money and there was a limit to how many sittings could be obtained, or how many corrections made – even assuming they might have been requested.

An objection from a patron would be more likely to arise over a feature, perhaps in the background of a portrait, which was simply not liked. For example, in the mid to late 1820s, Frederick Simcox Lea – husband to the *Mrs Elizabeth Lea* mentioned on p.43 – objected to a feature in the background of his portrait by Constable.[62] Though conceived as a pair to that of his wife and children in their Hampstead drawing room, Lea by contrast was to be shown on Hampstead Heath, and into this landscape Constable also introduced a distant thunderstorm. Lea objected to the inclusion of the storm. As pointed out by the Constable specialist Charles Rhyne, rather than painting out the offending thunderstorm, Constable started an entirely new version of the picture – just as had done when, a few years earlier, Bishop Fisher had objected to the 'black cloud' in the artist's first version of his *Salisbury Cathedral from the Bishop's Grounds* (1822–3; Victoria and Albert Museum, London).[63] Constable's fee for the portrait was not paid until he had delivered the revised version.[64] An interesting coda is that, some years later, Constable decided to paint

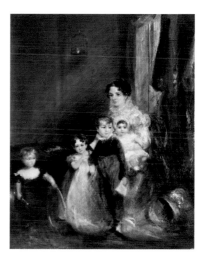

Maria Constable with Four of Her Children
John Constable, *c.*1823
Oil on canvas
622 × 508mm (24½ × 20")
Whereabouts unknown

out the figure of Lea in the rejected version and replace him with an open book, and this composition has a remarkable similarity with that adopted for the late portrait of his son, Charles Golding (plate 46).[65]

Much as Constable favoured the 'three-quarters' format, and even though he sometimes used the smaller 'head' size, he also worked from time to time on even smaller sizes than these, especially when painting portraits of intimate friends where the issue of a fee did not arise. These smaller sizes might be exactly half a 'head' size – that is, 12 × 10 inches (305 × 254mm) – or even smaller than that. After all, any size, small or large, could be cut as needed off a roll. His remarkable portrait of *Maria Bicknell* (plate 27), which measures 12 × 10 inches, was painted in 1816 as a love token, and for that reason no doubt needed to be eminently portable – we know that Constable took the picture with him to East Bergholt on the eve of their marriage. Of course, the small scale of the painting would if anything have increased the intimacy of the viewing experience, in much the same way that sixteenth-century portrait miniatures in watercolours were designed to be enjoyed in private.

Constable's portraits of John and Mary Fisher (plates 29 and 30), meanwhile, at 14⅛ × 12 inches (359 × 305mm) a little larger than that of Maria, are probably small because they were similarly made as tokens of friendship – the modest scale perhaps serving to make them more acceptable to the recipients as gifts. It seems likely that they were painted as wedding presents for the Fishers. Archdeacon John Fisher and Mary Cookson had married on 2 July 1816, just three months to the day before Constable and Maria's own wedding ceremony in London on 2 October, which Fisher himself performed. During that autumn, Constable and Maria spent an extended honeymoon with the Fishers at the Rectory in Osmington, Dorset, one of the Archdeacon's livings (see plate 31). After receiving such convivial hospitality – not to mention the existence of a strong bond of friendship between the couples – it is well nigh inconceivable that Constable would have accepted payment for the portraits. However, we do know that Fisher offered £3 towards the cost of the frames for the paintings, which were eventually delivered towards the end of 1817 by the ever dilatory 'Old Smith', a frame-maker in London who Fisher's uncle, Bishop Fisher, was in the habit of using, despite the many frustrating delays involved.[66]

It is usually assumed that the two portraits of John and Mary Fisher were painted during the Constables' stay with the couple in

Osmington in the autumn of 1816. Whilst there are references to the portrait of *Mary Fisher* (plate 30) having been painted at that time, a letter from Constable to Maria on 20 September 1816 indicates that the portrait of *Revd John Fisher* (plate 29) was already in existence by that date, this is, even before their visit to Osmington: Constable tells Maria that Fisher had been encouraging his uncle, 'the Bishop [to] sit to me for his picture in consequence of mine'.[67] It seems likely that Fisher would have sat to Constable in London earlier in the summer, increasing the likelihood of the portrait being made as a wedding present. Constable would then only have needed the opportunity to paint Mary to complete the pair. Meanwhile, Constable's portrait of *Dr Herbert Evans* (plate 44), though painted some years later in 1829, is on a similarly small scale and raises the question as to whether it, too, might have been painted as a gift. It could well have been offered in gratitude for medical services rendered as family tradition relates, especially since Evans was fast becoming a close friend to the artist. By contrast, it seems more likely that Constable would have accepted a fee for his portrait of *Mrs Evans* (1829; Private Collection), the doctor's mother, even though it is on a similarly small scale.[68]

It is indicative of the private, personal – and, in his early years, the local – aspects of Constable's portrait commissions that he very rarely decided, or needed, to exhibit them. The Royal Academy was the key venue in London where artists showed their work – in an annual exhibition that opened at the beginning of May. On the top floor of the purpose-built Somerset House in the Strand, the Academy had a suite of exhibition rooms, of which the grandest and most prestigious was the top-lit Great Room. It was here that, over the years, many of Constable's landscapes were first exhibited, including his famous 'six-footers'. In the late eighteenth century, the exhibition walls were dominated by portraits (see p.53), especially in the Great Room, and though landscape was gradually to become more popular, things were slow to change.[69] In May 1803, Farington noted in his *Diary* that 'Constable called – Had been to the Exhibition, thinks Portraits prevail too much'.[70]

As is the case today for exhibitions at the Royal Academy, in Constable's day not everything on display was for sale. Commissioned portraits, in particular, had usually been paid for by the time they were shown at the Academy.[71] They tended to be exhibited, then, not for sale purposes but either at the request of the patron – or indeed even at the desire of the artist – who presumably wanted them to become

a talking point, for the exhibitions were well attended and widely reviewed. The portraitist might receive further commissions on the strength of the exhibited picture. Since Constable managed to procure more than enough portrait commissions through recommendation, however, he did not need to advertise his work in this way. He exhibited examples of his portraiture only twice during the course of his lifetime: once in 1817, when he showed the portrait of *Revd John Fisher* (plate 29) at the Royal Academy; and the second time towards the end of his life, in 1836, when he sent the portraits of *Frederick Simcox Lea* (*c*.1829–30; Private Collection) and of *Mrs Elizabeth Lea with Her Three Children* to the Worcester Institution.

Constable's motive for exhibiting the Leas is likely to have been one of sheer practicality. He had first met and painted the Leas in Hampstead. However, by 1836 they had moved to Worcestershire, so it made sense to borrow pictures from a local source when assembling some examples of his work to exhibit at the Worcester Institution – the invitation to show there arising as a result of some lectures Constable had given at the Worcester Athenaeum two years before. His decision to send the portrait of Fisher to the Academy in 1817, however, is more intriguing. Constable may have submitted it purely as a gesture of friendship. However, as he had already given the picture to Fisher as a gift, he would have needed the latter's co-operation to part with it for a few months, separating it from its companion portrait, *Mary Fisher* (plate 30). Perhaps Fisher encouraged Constable, recently married and likely to be in need of funds, to 'advertise' this unfamiliar aspect of his work to a wider public in the hope of eliciting more commissions.

It must have been a bonus that the portrait of Fisher was hung in the Great Room at the Royal Academy that summer. The critics failed to notice it, but this hardly mattered.[72] With Constable's own network of contacts – not to mention those of John Fisher and his uncle the Bishop as well – he could always depend on new commissions. As has been noted, in 1817–18 he took on seven new portrait commissions in close succession, again mainly through local Suffolk connections. *Mrs James Pulham Snr* (plate 32) was the wife of his great Suffolk friend, James Pulham, whilst the family trio of *Revd Dr William Walker*, *Mrs Tuder* and *Mrs Edwards* (see p.26 and plates 34 and 35) can probably be explained by the fact that Walker was Rector of Layham near East Bergholt. However, the commission to paint *Revd Dr John Wingfield* (see caption to plate 33 on p.125) is more likely to

have come through a connection either with H.G. Lewis, or – perhaps more likely still – the Fishers. Certainly when Dorothy Fisher, the Bishop's daughter, saw the portrait of the Revd Dr Wingfield (and another male portrait) in Constable's studio in Keppel Street in 1818, as well as expressing her own admiration for both pictures, she also passed on glowing compliments from her father.[73]

It is likely that all these clients – or friends of friends – would have sat to Constable in London at his house in Keppel Street in Bloomsbury where he seems to have set up his studio on one of the upper floors.[74] This was exactly the period when Constable was working on the first of his large-scale landscapes, *The White Horse* (1819; The Frick Collection, New York), so they might well have caught a glance at this 'six-footer' – or its full-scale preparatory sketch –

The Exhibition of the Royal Academy
Pietro Antonio Martini after Johann Heinrich Ramberg, 1787
Hand-coloured etching
379 × 528mm (14⅞ × 20¾")
The British Museum, London

ΟΤΛΣΙΣ–ΑΜΟΤΣΟΣ–ΕΙΣΙΤΩ
THE EXHIBITION OF THE ROYAL ACADEMY, 1787.

as it was taking shape. If so, they would have been unlikely to realize what an important new step Constable had now taken in his landscape work. For, from 1819 until the early 1830s – circumstances permitting – Constable would devote the great bulk of his time, ambition and emotional energy into producing a large-scale landscape for each year's exhibition at the Royal Academy. All other commissions – be these for portraits or smaller format landscapes – were made to take a back seat. As indicated in Martin Gayford's essay (see p.14), it was clear that Constable felt these commissions – which he dismissively referred to in his letters as 'jobs' or 'dead horses' – simply distracted him from his core aim, the annual production of a six-footer. As he revealingly told Fisher in a letter of 1823, one of the rare years he had failed to produce a large landscape for the Academy exhibition owing to ill health: 'my difficulty lies in what I am to do for the world, next year I must work for myself – and must have a large canvas'.[75]

Financially speaking, this was a gamble. Indeed, from 1825, when Constable painted *The Leaping Horse* (Royal Academy of Arts, London), all his large landscapes were to remain unsold. Furthermore, however many legacies Constable and Maria might receive – and, after Golding Constable's legacy in 1816, there were two more, quite substantial bequests from the Revd Dr Durand Rhudde and Charles Bicknell – there was never enough money.[76] Constable continued therefore to accept portrait commissions in the second half of his life. Indeed, about forty per cent of the 100 or so portraits he is known to have painted date from the years after his marriage. From 1822, many of these would have been painted in Charlotte Street, Constable having taken over the lease of Farington's house at number 35 that year. Indeed, for the first time in his life, Constable now had a purpose-built studio, and thus, no doubt, proper facilities for receiving friends and clients who might come to have their portraits painted. William Lambert, for example, would almost certainly have sat to Constable in Charlotte Street, since we know that his portrait was painted in London – unlike that of his three grandchildren.[77]

Generally speaking, however, the number of portrait commissions Constable was prepared to take on was now reducing. Their scale was also smaller – as far as we know, Constable was never to paint a portrait larger than a 'three-quarters' in the second half of his career. It is perhaps ironical that, just when he now had the facilities for setting up a proper portrait practice, his heart – and stamina – for the task were fast diminishing. From now on, it seems, he only accepted

commissions if the sitter was congenial or a good friend, such as Dr Evans; or if he felt he could not refuse them, such as in the case of the Lambert family portraits and those, presumably, of the Leas – not to mention the commission to paint the father of the little respected lawyer, John Mirehouse, who was related by marriage to the Fisher family.

The two portraits of the Lea family, and those of Dr Evans and his mother – all no larger than 'head' size – would probably have been painted by Constable in Hampstead, where he was now spending much more of his time. He still had many commitments in central London, however, so continued to keep on his house and studio in Charlotte Street. Once elected a full Royal Academician in 1829, he had many meetings and functions to attend at Somerset House, and in the 1830s twice served as 'Visitor' in the Academy Schools, setting the poses of the models and developing a new teaching course. He also delivered a course of lectures at the Royal Institution. It was at Charlotte Street, indeed, that Constable died, unexpectedly, on 31 March 1837, having only the previous night attended the General Assembly of the Academy at its new premises at Trafalgar Square. The obituary for the *Morning Herald* of 3 April described the early years of his training at the Royal Academy, noting that 'his improvement was rapid'. 'He commenced portrait painter [*sic*],' the obituary continued, 'which he followed with much success for some years, but his taste was decidedly for landscape painting, and he finally abandoned the more lucrative walk of portraiture for the more agreeable and congenial one of which he was so fond.'[78]

Constable would surely have concurred with this assessment. Had he not told Maria, as far back as 1812, that whilst his father was always anxious to see him 'engaged in Portrait … you know Landscape is my mistress – 'tis to her I look for fame'.[79] His ambition was of course fulfilled. It was for his landscapes that he was remembered at the time of his death and it is chiefly as a landscape painter that Constable is, justly, most celebrated today. It was also in 1812, having received some particularly complimentary remarks about one of his portraits, that Constable told Maria that such praise 'could make me vain of my portraits – but you know I am "too proud to be vain".'[80] Now, with some of his finest portraits being gathered together for the first time, it is to be hoped that we may be vain on his behalf.

Notes

1 JCC II 1964, pp.96–7 (letter to Maria Bicknell, 17 November 1812). See also Bailey 2006, pp.64–5.

2 JCC I 1962, p.84 (letter from Ann Constable, 12 November 1812).

3 Farington, *Diary*, vol.12, p.4252.

4 JCC VI 1968, p.78 (letter to John Fisher, 23 October 1821).

5 J.T. Smith, *A Book for a Rainy Day* (London, 1845; 1905 edition), p.136 (cited in Cormack 1986, p.21).

6 Allen in Strong et al. 1991, pp.132–3.

7 M. Pointon, 'Portrait! Portrait!! Portrait!!!' in Solkin (ed.) 2001, p.97 and *passim*; also Pointon 1993, p.39.

8 Farington, *Diary*, vol.4, p.1129 (6 January 1799), cited in Cormack 1986, pp.32–3.

9 For references to 'fame and gain', see for example JCC I 1962, p.86 (letter from Ann Constable, 30 November 1812).

10 JCC I 1962, p.63 (letter from Ann Constable, 28 April 1811). For Constable's altarpiece of *Christ Blessing the Children*, see Reynolds 1996, no.05.2. For West's altarpiece of *Christ Healing the Sick*, see H. von Erffa and A. Staley, *The Paintings of Benjamin West* (New Haven and London, 1986), no.336, oil on canvas, 2740 × 4270mm (108 × 168˝). The painting, now in the Tate, was badly damaged in a flood of 1928.

11 JCC II 1964, p.87 (28 September 1812).

12 Pointon 1993, p.36.

13 JCC II 1964, pp.27–8.

14 Ibid.

15 Leslie 1951, p.12n.

16 For the Academy life drawings, see Reynolds 1996, nos 00.18–00.24, 08.20–29, 08.32 and 08.36–51, and Reynolds 1984, nos 20.14 and 20.61–7; and for the Academy studies in oils, see Reynolds 1996, nos 08.30–31 and 08.33–5, and Reynolds 1984, no.31.19.

17 An important early local landscape commission is the oil of *Old Hall, East Bergholt* painted for John Reade, the Hall's owner (R.01.01). Constable also made finished watercolours of local scenery as wedding presents (see R.00.4–7 and R.00.9).

18 Farington, *Diary*, vol.6, p.2340 (1 June 1804).

19 Ibid.

20 Reynolds 1996, nos 04.04 and 04.12–13.

21 For example, *Portrait of a Lady* in the Tate Gallery, London (NO.4954) once ascribed to Constable, and said to be after Daniel Gardner, is now attributed to Gardner himself (R. Edwards, 'A Portrait by John Constable at the Tate Gallery', *Burlington Magazine*, vol.LXXIV, May 1939, pp.203–4).

22 Both drawings show Mary Ann Bridges at the harpsichord with two of her sisters (Reynolds 1996, nos 04.02–3).

23 Allen in Strong et al. 1991, p.171; and Pointon 1993, p.47. However, it seems likely that Constable would have started the portraits using drawn outlines, and that these are now obscured by layers of paint.

24 *Charles Lloyd* (Reynolds 1996, no.06.288), *Sophia Lloyd and her Child* (R.06.289), *James Lloyd* (R.06.290), *Susannah Lloyd* (R.06.291) and *Priscilla Wordsworth, née Lloyd* (R.06.292).

25 FDC 1975, pp.114–15 (letter from Peter Firmin to John Constable, 30 August 1807).

26 Ibid.

27 Reynolds 1996, no.07.08.

28 JCC II 1964, pp.105–6 (letter from John Constable to Maria Bicknell, 13 May 1813) and Farington, *Diary*, vol.12, p.4349 (13 May 1813).

29 See N. Penny (ed.), *Reynolds* (exh. cat., Royal Academy of Arts, London 1986), no.167a, p.337.

30 Reynolds 1996, no.12.62.

31 Ibid., no.12.64.

32 Wilkie's journal, cited in FDC 1975, p.314.

33 JCC II 1964, p.64 (16 April 1812).

34 Ibid., p.70 (27 May 1812).

35 Ibid., p.75 (15 June 1812).

36 Ibid.

37 JCC IV 1966, pp.66–7 and 78.

38 JCC II 1964, p.109 (30 June 1813).

39 Ibid. For comparisons with Lawrence, Hoppner and Beechey, see Cormack 1986, p.34.

40 Constable's reference to the price of fifteen guineas for a head, cited in his letter to Maria Bicknell of 30 June 1813 (see note 39 above), comes immediately after he has mentioned his portrait of *Revd George Bridgeman* (Reynolds 1996, R.13.11), which is painted on the so-called 'three-quarters' scale of 30 × 25˝ (762 × 635mm). Jacob Simon has observed that three-quarters of a yard is 27 inches, which is the amount of material required to produce a 25-inch-wide canvas of upright format once allowance has been made for about an inch of turnover on each (widthways) side of the canvas so as to fix it onto a wooden stretcher.

41 See, especially, S. Cove in Tate 2006, 'The Painting Techniques of Constable's "Six-Footers"', pp.54–5 and ff. For artists' suppliers canvas advertisements, see L. Carlyle, *The Artist's Assistant: Oil Painting Instruction Manuals and Handbooks in Britain 1800–1900 with Reference to Selected Eighteenth Century Sources* (London, 2001), pp.447–9.

42 For *Mrs Elizabeth Lea with Her Three Children*, see Reynolds 1984 no.30.19, and for *The Lambert Children*, see R.25.13.

43 The Colchester picture is not individually catalogued by Reynolds but is mentioned under Reynolds 1996, no.04.11, where he suggests it is a later copy after 04.11, the Tate version. However, Leslie Parris suggested that the Colchester version was the original one, a theory accepted here (see L. Parris in *The Tate Gallery 1984–86: Illustrated Catalogue of Acquisitions*, 1988, pp.19–20).

44 Both pictures descended through the family to Hugh Golding Constable (1868–1949), who sold them at Sotheby's on 1 December 1926 where they were consecutive lots (nos 149 and 150). They were both purchased at the sale by P.G. Laver and given by him to the Colchester Museum.

45 JCC II 1964, p.159 (John Constable to Maria Bicknell, 3 November 1815): 'Mary Constable has just had a letter from Miss Savile at Berlin. [Her] letter is a very affectionate tribute to the memory of my dear Mother. She has requested a portrait of her and my father from those we have here.'

46 For the reduced-scale copy, now in the Henry E. Huntington Library and Art Gallery, San Marino, see Reynolds 1996, no.18.37, and Asleson and Bennett 2001, no.5, pp.46–9.

47 For the original version, see Reynolds 1996, no.09.24. The version made for Lord Bradford, R.09.25 – and plate 23 in this book – is the first replica. For subsequent replicas, see R.13.28 and Reynolds 1984, no.27.46.

48 Reynolds 1996, no.13.11.

49 For *Sheffield Neave*, see Reynolds 1984, no.25.30, and *Charles Bicknell*, R.25.31.

50 See Reynolds 1984, no.25.14.

51 This tends to be supported by the fact that Constable charged about £25 for the portrait of *Thomas Simcox Lea*, Reynolds 1984, no.30.18, and would presumably have charged a similar sum for his portrait of *Mrs Elizabeth Lea with Her Three Children* painted a few years earlier (R.30.19). See Paris 2002, pp.200–01.

52 Pointon 1993, p.48.

53 JCC II 1964, p.130 (28 August 1814).

54 Ibid., p.375 (Maria Constable to John Constable, 22 January 1825).

55 For *Eliza O'Neill*, see Reynolds 1996, no.15.51. See also JCC II 1964, p.142 (letter from John Constable to Maria Bicknell, 17 June 1815).

56 JCC II 1964, p.144 (letter from John Constable to Maria Bicknell, 28 June 1815).

57 The Revd Andrew's publications by this date included *Astronomical and Nautical Tables* (1805) and *Institutes of Grammar and Chronological Tables* (1817), see Parris 1981, p.76.

58 Cove in Tate 2006, op. cit. note 41, p.56 and ff.

59 For the fullest discussion of this method of working, see Tate 2006.

60 For example, *The Leaping Horse* (1825), Reynolds 1984, no.25.1, and *The Opening of Waterloo Bridge* (c.1820–5), R.32.2 (see Tate 2006, cat. nos 47 and 65).

61 *Study for the Lambert Children*, oil with scratching out on laid paper, 165 × 130mm (6½ × 5⅛″), Sotheby's, 22 March 2000, lot 27.

62 For *Thomas Simcox Lea*, see Reynolds 1984, no.30.18.

63 Rhyne 1988, pp.21–3. For *Salisbury Cathedral*, see Reynolds 1984, no.23.1.

64 Paris 2002, pp.200–01.

65 Rhyne, op. cit. note 63.

66 JCC II 1964, p.229 (letter from John Constable to Maria Constable, 10 July 1817). There are various references to 'Old Smith' in the collected Constable correspondence, especially in JCC VI 1968. It seems that Bishop Fisher continued to use the Smiths, 'Father and Son', despite the delays involved, as they owed him 'a large Sum of money', which he was anxious to have repaid 'by their working it out for me' (ibid., p.102, letter from Bishop Fisher to John Constable, 10 November 1822).

67 JCC II 1964, p.208; in other words, John Fisher had recently been encouraging his uncle, Bishop Fisher, to sit to Constable for his portrait on the strength of the portrait Constable had recently painted of him.

68 For *Mrs Evans*, see Reynolds 1984, no.29.52.

69 For a discussion of the Royal Academy exhibitions at this date, see Solkin (ed.) 2001. In 1783, portraits made up nearly forty-five per cent of the exhibits at the Academy exhibition – even more if miniatures are taken into account (Pointon 1993, p.38).

70 Farington, *Diary*, vol.6, p.2031.

71 M. Pointon, 'Portrait! Portrait!! Portrait!!!', op. cit. 2001, p.94.

72 The full range of contemporary critical commentary on Constable's work is found in Ivy 1991.

73 JCC VI 1968, p.37 (letter from Dorothea Fisher to John Constable, n.d. [1818]).

74 Cove in Tate 2006, p.52.

75 JCC VI 1968, p.133 (30 September 1823).

76 The Revd Dr Rhudde left Maria £4,000 of stock, which gave an income of approximately £120 a year. Charles Bicknell bequeathed £20,000 to Constable, Maria and their children.

77 See under Reynolds 1984, no.25.14, and also Sotheby's, 13 March 1985, lot 75.

78 Ivy 1991, p.225.

79 JCC II 1964, p.87 (28 September 1812).

80 Ibid., p.80 (10 July 1812).

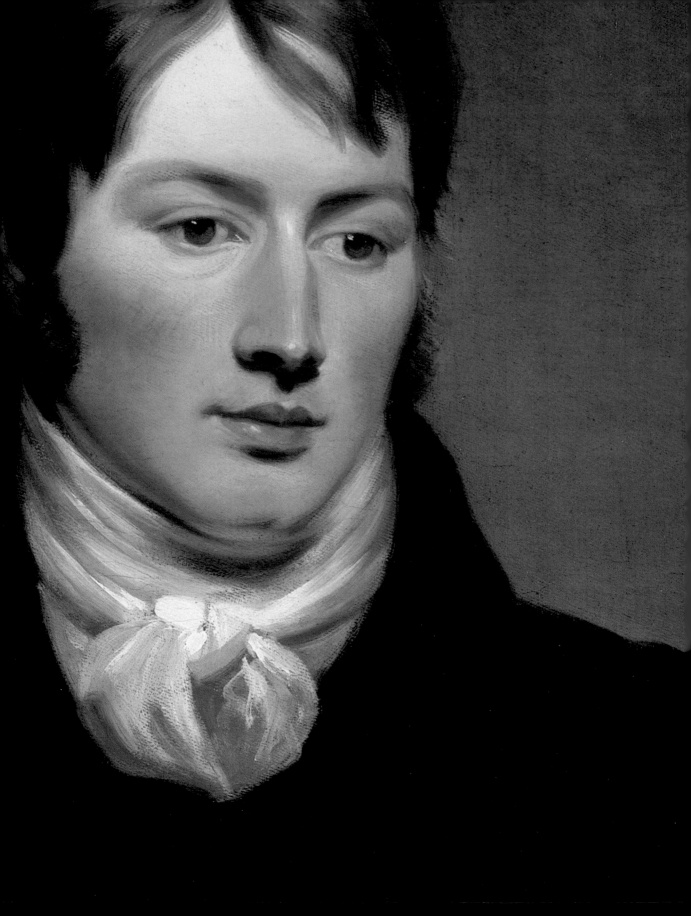

Constable: The Young Man

1 John Constable (1776–1837)

RAMSAY RICHARD REINAGLE

1799

Oil on canvas, 762 × 638mm (30 × 25⅛")
National Portrait Gallery, London (NPG 1786)
Purchased with help from The Art Fund, 1917

After leaving school, John Constable worked for a while as supervisor of his father's windmill on East Bergholt Common. According to C.R. Leslie, he was then known locally as 'the handsome miller' and was 'remarkable among the young men of the village for muscular strength, and being tall and well formed, with good features, a fresh complexion and fine dark eyes, his white hat and coat were not unbecoming to him.'[1]

The basis for this description might have been this portrait from 1799 by Constable's contemporary and – for a short while – close friend Ramsay Richard Reinagle. The two men met shortly after Constable was admitted to the Royal Academy Schools in March 1799 and Reinagle spent the summer of that year as a guest of the Constables in East Bergholt.

By December, this painting had been completed; it was seen then by Ann Taylor, daughter of a dissenting clergyman living in the district. She visited the Constable house with four other young women to inspect Constable's work, his portrait and the artist himself, who was regarded as a most romantic figure. Ann Taylor recalled, many years later, that she had never met with so 'finished a model of what is reckoned manly beauty' as the youthful painter. The fact that his father was known to object to his choice of career gave him the added allure of 'a hero in distress'.[2]

The self-portrait drawing (plate 2) dates from seven years later, when the painter was approaching thirty. He presumably drew his own profile – his hair beginning to thin – by using two mirrors. Perhaps one of these was convex as his nose is distinctly exaggerated.

1 Leslie 1951, p.4.
2 JCC II 1964, p.17.

p.58: plate 1 (detail)

60

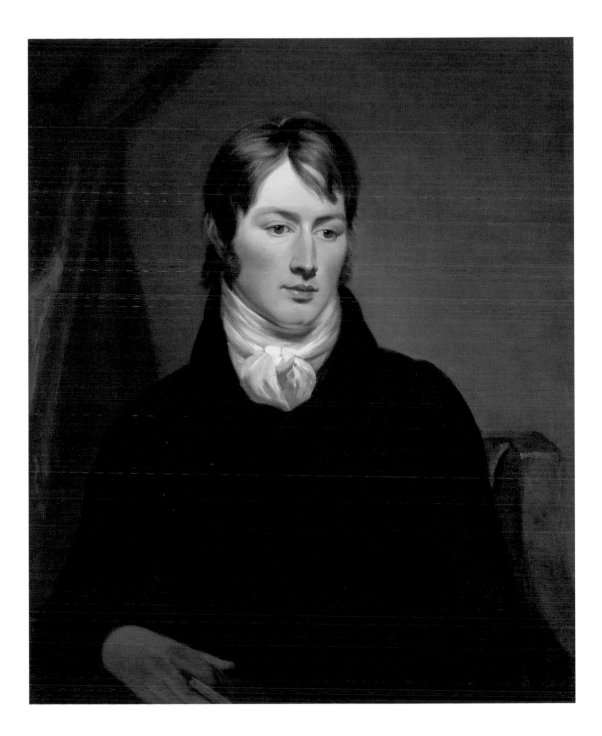

2 Self-portrait

1806

Pencil on paper, inscribed
'April [deleted] March 1806'
190 × 145mm (7½ × 5¾")
Tate. Purchased 1984
(R.06.2)

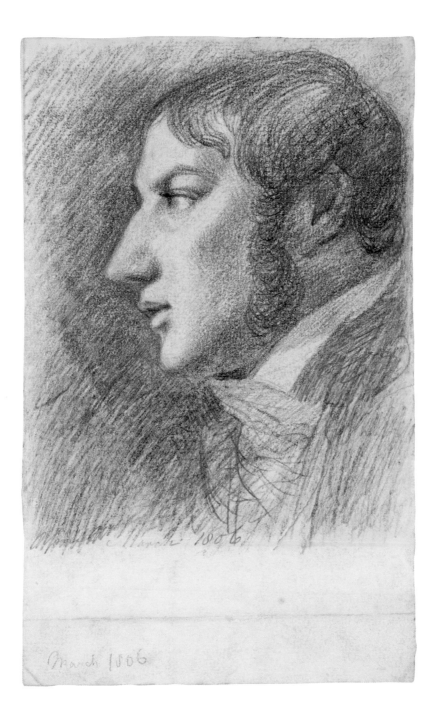

The Family at East Bergholt

3 Golding Constable (1739–1816)

c.1815

Oil on canvas, 759 × 632mm (29⅞" × 24⅞")
Tate. Purchased 1984
(R.15.9)

Mr Golding Constable was a substantial figure in the
East Bergholt area, as this forceful, confident portrait
suggests. Though Golding Constable was sometimes
described as a 'miller', that is a misleading term for
a man who was really a successful rural businessman
with many interests, including a fleet of barges on
the River Stour and a sea-going vessel, the *Telegraph*,
plying between the port of Mistley, Essex, and
London. John Constable described his father as
a 'merchant'; another common contemporary job
description was 'corn-factor'.

Constable states in a letter of 1815 that he is
painting a portrait of Golding Constable.[1] At that
stage, the sitter was seventy-six years old and in such
poor health that his life had been despaired of more
than once. This picture has often been assumed to
be the one he mentions, but it is hard to accept it
as a portrait of a man in his mid-seventies who had
recently been critically ill. On the contrary, it seems
to depict a hearty, vigorous man in late middle age.
A possible solution to the puzzle is that this is a
memorial portrait of the patriarch of the Constable
family, perhaps made after his death and depicting
him in his prime.

1 JCC II 1964, p.140 (letter to Maria Bicknell, 21 May 1815).

p.64: plate 7 (detail)

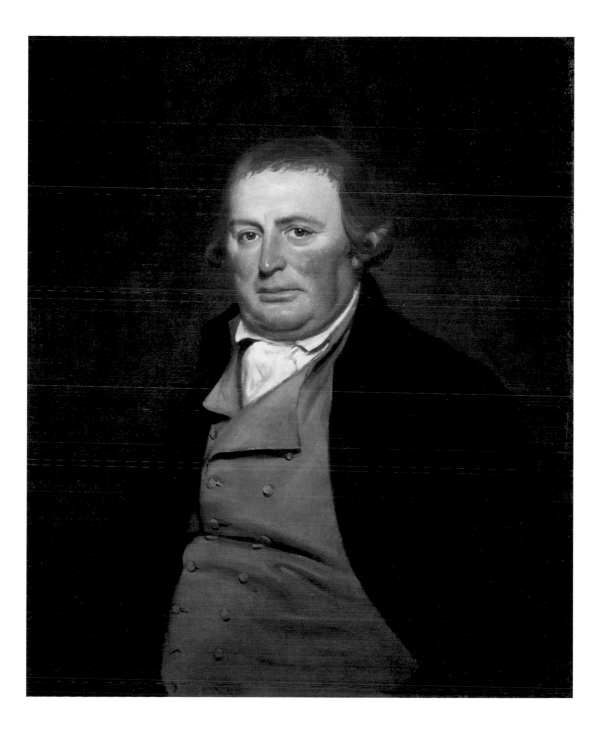

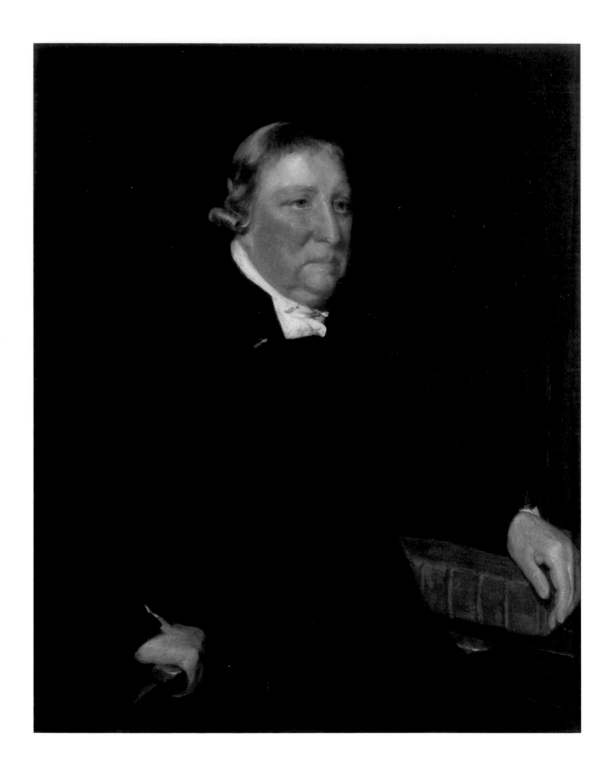

4 Golding Constable(?), Previously Identified as Dr Grimwood

?1800–07

Oil on canvas, 921 × 733mm (36¼ × 28⅞")
Colchester and Ipswich Museum Service
(R.05.57)

In the past, this painting was thought to represent Dr Thomas Lechmere Grimwood (d.1809), the headmaster of Dedham Grammar School, based on its description in a 1926 sale catalogue 'Portrait of the artist's schoolmaster'. But as Anne Lyles argues (see pp.43–4), there are good reasons to think that it is in fact a picture of the painter's father. It has a strong resemblance to the other portrait of Golding Constable – same brown curled wig, same jowls. The sitter looks, if anything, older than the man shown in plate 3. However, the painting's larger size and stiffer handling suggest an earlier date, and it may have been painted by Constable as a pair to an early picture of his mother, Ann (see p.43).

5 East Bergholt House

c.1809–11

Oil on millboard laid on panel
181 × 505mm (7⅛ × 19⅞")
Victoria and Albert Museum:
Given by Isabel Constable
(R.10.28)

Golding Constable began his family life in the mill-house at Flatford, which he had inherited from his uncle in 1765. But after living there for nine years, in 1774 Golding built a new three-storey brick mansion up the hill in the village itself, which he named 'East Bergholt House'.

Four-square, plain and substantial, the structure resembled Golding himself. This was where his second son, John Constable, was born in 1776. The family house was the background to the painter's childhood and long periods of his life before his marriage to Maria Bicknell in 1816.

Constable made numerous paintings and drawings of the family dwelling, by night and day, and mainly – as in this example – from the fields behind the house. In this painting, dating probably from 1809 to 1811, the village church can be seen to the left and the Constables' barn and two of their cows to the right. Constable loved the house, as he did the landscape around, for the memories and associations it held.

The Garden of
East Bergholt House

(ILLUSTRATED OVERLEAF)

These two landscapes depict the panorama from rooms at the rear of East Bergholt House – a view deeply familiar to Constable from childhood. The fields directly behind the house – amounting to 37 acres – were owned by his father, so too was the brick barn to be seen beyond the flower garden, and the windmill in the distance to the rear of the kitchen garden.

Constable's mother, Ann, suffered the first symptoms of the stroke from which she died while she was working in the flower garden on the morning of 9 March 1815. These pictures were painted later in that year and are valedictory in more than one sense. The 'Flower Garden' (plate 6), the first to be painted – perhaps in July as the corn is still green – depicts the scene of Mrs Constable's fatal attack. It is set at evening, the garden itself in deep shadow and a dark cloud in the distance.

During the same year, it became evident that, to maximize their inheritance from Golding Constable's estate, his children would have to sell the family house. Since it was clear that the old man would not live for much longer, Constable must have been aware that this was one of the last occasions on which he would look out on this view.

Constable at this time was experimenting with painting large pictures completely in the open air. But it was obviously easier to paint a landscape from indoors, looking out as he did when painting these images of the Constable garden. They are at once studio pictures and direct studies of the landscape.

The 'Vegetable Garden' (plate 7) was probably painted in August and from slightly higher up than the 'Flower Garden' – presumably Constable worked from the floor above. In the centre of the painting, nestling in a wood, can be seen the Rectory, where lived Maria Bicknell's grandfather, the Revd Dr Durand Rhudde. It was in the fields between that Constable and Maria (his wife-to-be) walked so happily together in 1809.

6 Golding Constable's Flower Garden

1815

Oil on canvas, 331 × 507mm (13 × 20")
Colchester and Ipswich Museum Service
(R.15.22)

7 Golding Constable's Vegetable Garden

1815

Oil on canvas, 331 × 507mm (13⅛ × 20″)
Colchester and Ipswich Museum Service
(R.15.23)

8 Abram Constable (1783–1862)

1806

Oil on canvas, 760 × 635mm (29⅞ × 25″)
Colchester and Ipswich Museum Service
(R.06.295)

Abram was the beau of the three Constable brothers.
He was a keen attendee of routs and balls, as is often
mentioned in letters to John in London. 'Abram is
our only Male amongst the youthful parties', wrote
Ann Constable, mother of the family, on 8 January
1811, 'last Thursday old Mrs. Harvey, last night
at Mr. Clark's, on Wednesday the 16th a dance at
Mrs. Wilkins at Dedham, and so on.'[1] (The more
serious-minded John usually shunned such occasions.)

This portrait suggests that, like his older brother
John, Abram was a handsome young fellow. It seems
to show a sitter in his early twenties, so a date around
1806, when Abram was twenty-three, is quite plausible.

Abram's energy, kindliness and good sense made
Constable's career as a painter possible. Had the
youngest of the Constable brothers not been so
evidently capable, presumably John would have had
to follow his father into the family business. Without
Abram's generosity in continuing to run the mills and
barges, and providing his siblings with an income,
John's later life and marriage would have been much
less comfortable.

Despite his love of parties and dashing good looks,
Abram remained unmarried. He retired and sold his
businesses in 1846, and lived on in East Bergholt –
a notable local figure – until he was almost eighty.

1 JCC I 1962, p.55.

74

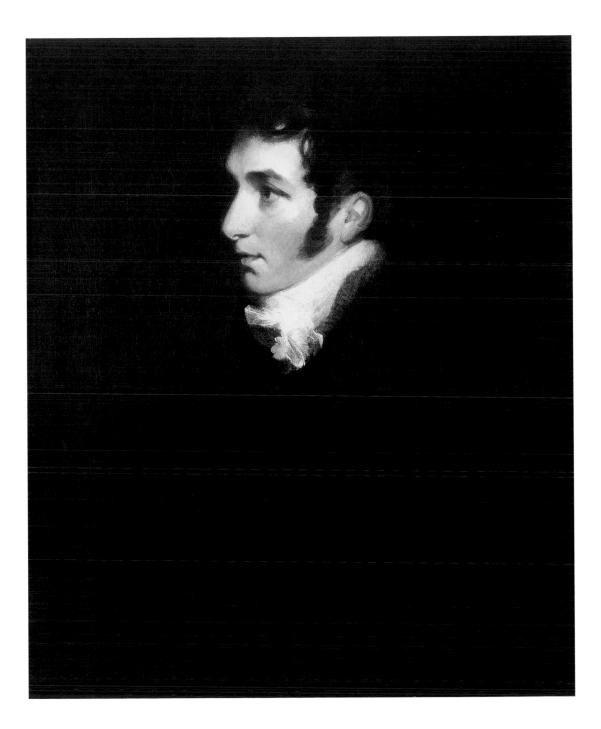

Ann (1768–1854) and
Mary (1781–1865) Constable

c.1814

Oil on canvas, 900 × 695mm (35⅜ × 27⅜")
Trustees of the Portsmouth Estates
(R.14.52)

Of John Constable's three sisters, only one, Martha or Patty (1769–1845), married (to a London cheese-monger named Daniel Whalley). Unfortunately there is no surviving portrait of her. He does not seem to have been close to the oldest, Ann, who was eight years his senior. But Constable appears to have been fonder of his youngest sister, Mary. His earliest portrait of her, on grounds of style and the apparent age of the sitter, seems to be the vigorous, brushy head in the Victoria and Albert Museum, possibly from around 1806 when she was twenty-five (plate 10).

Mary is the only member of the family to address Constable in a letter as 'Dearest Johnny', and it was Mary who was dispatched to keep him company in 1812 in his London lodgings. The previous year, the apparent hopelessness of John's love for Maria Bicknell had reduced him to a condition of worrying depression and debility – pale, thin and lacking in energy.

He had re-established contact with Maria in October 1811 and seen her on several occasions. But it was still thought a good idea for Mary to spend the spring with him in his lodgings at 63 Charlotte Street.

She arrived by 20 January and remained – with a trip to visit relations in Epsom – until May. Towards the end of this period, Constable did a series of charmingly intimate drawings of Mary in his Charlotte Street rooms.

The example included here (plate 11) is dated '22d Apl. 1812'; another showing her reading a letter is inscribed with the same date, with '- C- St.' added (R.12.11). A third shows her wearing the same dress with fur tippet, also reading at an open drawer (R.12.14).

The double portrait of Ann and Mary – the two Constable sisters still living at East Bergholt – was completed by February 1815 when it was dispatched in a packing case to Charlotte Street. It was presumably painted the previous summer or autumn, when Constable spent from 30 July to 4 November in East Bergholt. The beautiful full-length study of Mary (plate 12), her head turned away, might have been done at the same time as she is wearing the same cloak and carrying the same bonnet as in the other picture (the identification was first suggested in Asleson and Bennett 2001, p.48).

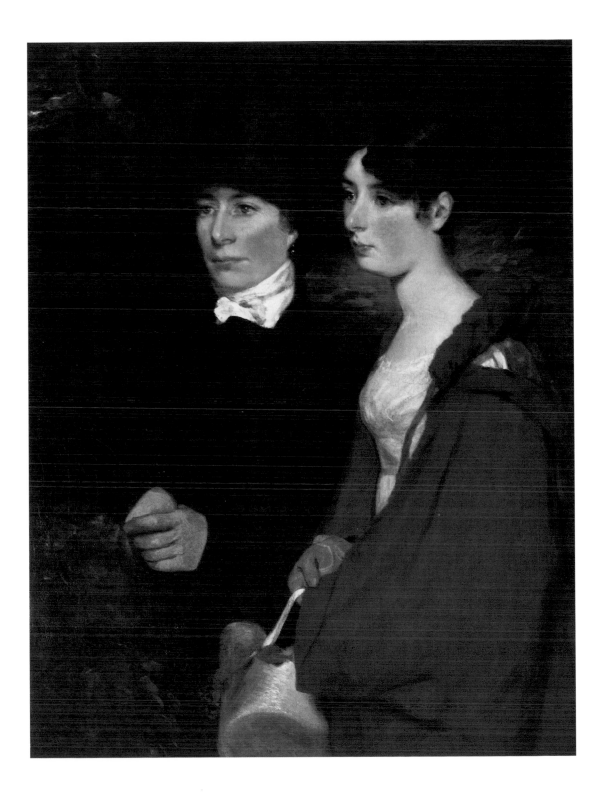

10 Mary Constable

*c.*1806

Oil on canvas, 312 × 305mm (12¼ × 12")
Victoria and Albert Museum:
Given by Isabel Constable
(R.06.298)

11 Mary Constable

1812

Pencil on paper, inscribed '22d Apl. 1812'
152 × 91mm (6 × 3⅝")
The Samuel Courtauld Trust
The Courtauld Gallery, London
(R.12.12)

**12 A Girl in a Red Cloak
(Mary Constable)**

c.1809–14

Oil on card, 298 × 141mm (11¾ × 5½")
Private Collection
(R.09.41)

Friends and Early Group Portraits

13 Ladies of the Mason Family

c.1805–6

Oil on canvas, 595 × 495mm (23⅜ × 19½")
Colchester and Ipswich Museum Service

This, the most engaging of Constable's youthful attempts at group portraiture, represents members of his extended family. William Mason, a local solicitor, was married to the painter's first cousin, Anne Parmenter (1770–1857). The family lived at Jupe's Hill, between Dedham and Manningtree – and an easy walk from East Bergholt – and also had a house on Church Street in Colchester, where William Mason was a prominent local figure. In 1815, he was repeatedly summoned to East Bergholt to consult with Golding Constable about the terms of his will – a document of enormous importance to John Constable. The Masons were therefore well known to the painter; Abram Constable thought them 'very worthy people', and 'almost my best friends in the County'.[1]

The ladies of the family are here engaged in suitable activities for female members of the Georgian middle class: one sewing, one reading, the others listening. They look like an illustration to a Jane Austen novel.

The older, sewing woman on the right is presumably the mother of the family, Anne – then about thirty-six (though it has been suggested she is Mary Constable). The oldest girl, Jane Anne (1792–1876), must be the figure standing on the left. Her apparent age suggests that this picture was painted around 1806, when she would have been fourteen.

1 JCC I 1962, p.25 (letter from Abram Constable, 19 June 1808).

p.82: plate 19 (detail)

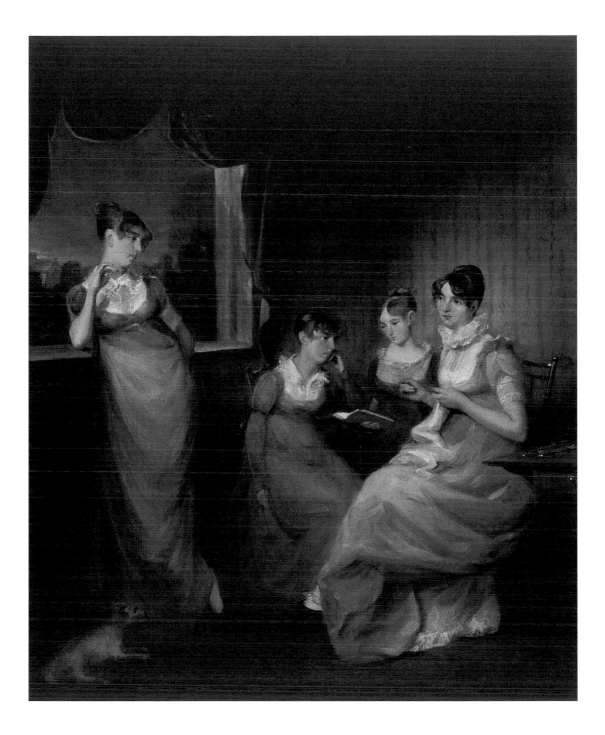

14 Jane Anne Mason (Mrs James Inglis) (1792–1876)

*c.*1808–9

Oil on canvas, 762 × 635mm (30 × 25")
Government Art Collection
(R.08.7)

Around two years after Constable painted the group portait of the Mason ladies (plate 13), in June 1808, Abram Constable wrote to his brother John mentioning that the Masons were coming to London and that he had given them John's address. He adds that '*Jane* is to be with them, and you will think her *grown*'.[1] His emphasis hinted that the girl – then sixteen – had suddenly blossomed into womanhood and was turning into a beauty.

It was either on the occasion of this family visit to London, or – more probably – when Constable went to Colchester at the end of October 1809, that he painted his cousin's portrait. The result is one of the most delightful of his early portraits – confirmation of an affinity at this stage of his life for pretty female sitters.

Subsequently, Jane Mason married James Inglis, who died in 1830 leaving her a widow with six children. The eldest of these – also named Jane – was lent a painting by Constable to help her practise her art. In recent years, this portrait of Jane Anne Mason hung at the head of the stairs at No.10 Downing Street.

1 JCC I 1962, p.25 (letter from Abram Constable, 19 June 1808).

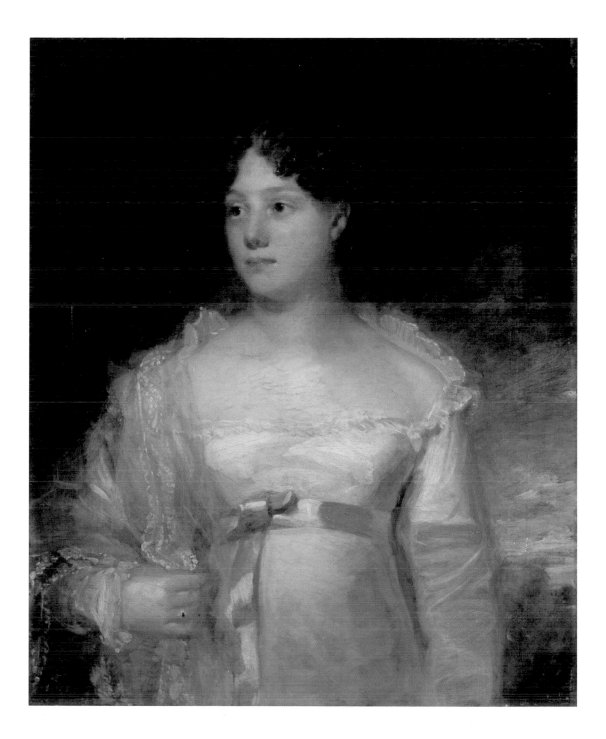

1806

Pencil on paper, 241 × 192mm (9½ × 7½")
The British Museum, London
(R.06.194)

Constable drew this impromptu music party while
on a trip to the Lake District in 1806. At the piano
is a gentleman named Richard Worden with whom
Constable had been staying; the figure standing
behind, singing, is probably an Irish painter named
Richard Shannon. The standing woman is Shannon's
sister, and the seated one Jessy, wife of John Harden
(1772–1847), an amateur painter and owner of
Brathay Hall near Windermere where Constable
was briefly staying.

He made a good impression on the Hardens,
sketching with John and painting Jessy's portrait. She
thought him 'a genteel handsome youth' – Constable
was then thirty – and 'a clever young man', though
she added that he painted 'too much for effect'.[1]

This little vignette, with its rapid, almost caricatural
notation of action and posture, suggests an aspect of
his talent that he didn't later explore: John Constable,
chronicler of the social scene. He was himself an
amateur flautist and took an interest in music, which
provided him with some memorable metaphors
for painting (that the sky gives the 'key note' to a
landscape, for example).[2]

1 Hebron et al. 2006, pp.32, 34.
2 JCC VI 1968, p.77 (letter to John Fisher, 23 October 1821).

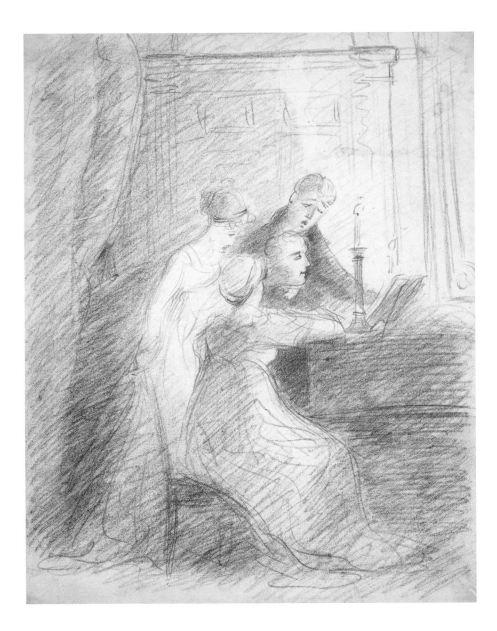

16 James Lloyd

1806

Oil on canvas, signed '[C]onstable f Decr 1806'
735 × 610mm (28 ⅞ × 24")
Birmingham Museums & Art Gallery
(R.06.290)

While at Brathay Hall, Constable met the poets
William Wordsworth (1770–1850) and Samuel Taylor
Coleridge (1772–1834) and their friend, a wealthy
amateur writer named Charles Lloyd (1775–1839).
He painted the portraits of Lloyd, his wife and his
sister Priscilla (who married Wordsworth's brother
Christopher). The Lloyds were Quaker bankers from
Birmingham who gave their name to the high street
bank of today. Later, on his return journey south,
Constable completed this Lloyd gallery by painting
other family members, including Charles's younger
brother James who was said to be an unhappy recruit
to business and indeed looks a little melancholy.

17 A Soldier Playing a Guitar

c.1806

Pencil on paper, 234 × 179mm (9¼ × 7")
The British Museum, London
(R.06.126)

Constable's sketching of social scenes was not confined to his visit to the Lake District in September and October 1806. During that year, he produced a flurry of such drawings, unique in his output as an artist – and indeed, as a man, he seems to have had an unusually sociable time. He spent time earlier in that year with the Cobbolds at Ipswich, then with his aunt, uncle and cousins the Gubbins at Epsom, and for over a fortnight in June and July with a building contractor named William Hobson and his family at Markfield House, Tottenham.

In all these places he drew people at rest, enjoying themselves or in conversation – and did so prolifically. Two intact sketchbooks survive from the sojourn at Markfield and one from his Epsom stay, plus other drawings. It is not quite clear why he – ostensibly a dedicated painter of landscape – produced such a quantity of figure studies. One explanation is that

Constable intended at that point to follow a parallel career as a specialist in group portraiture and conversation pieces – the successor of Zoffany and Hogarth.

It is true that some portrait commissions came out of these visits and that the drawings were useful five-finger exercises for an aspiring portrait painter. They also, however, seem to show signs of sheer pleasure in recording his human surroundings. Markfield House must have been a bustling dwelling, since the Hobsons had sixteen children of whom Joshua (b.1782) was the oldest. He was twenty-four when Constable drew him reading on a window seat – if the barely legible inscription identifies him correctly (plate 18).

The soldier playing the guitar to a young lady is it seems the 28-year-old James Gubbins, an officer in the 13th Light Dragoons, who was killed nine years later at the Battle of Waterloo. His companion might be one of his sisters, Anne Elizabeth or Jane.

18 Joshua Hobson Reading on a Window Seat

1806

Pencil on paper, inscribed by the artist 'Joshua'[?]
174 × 224mm (6⅞ × 8⅞")
The Samuel Courtauld Trust
The Courtauld Gallery, London
(R.06.76)

19 A Lady with a Parasol

c.1806

Watercolour on paper
154 × 109mm (6⅛ × 4¼")
The British Museum, London
(R.06.109)

20 A Mother with a Baby

*c.*1806

Pencil on paper, 234 × 188mm (9¼ × 7⅜")
The British Museum, London
(R.06.127)

21 Master Crosby

1808

Oil on canvas, signed 'J. Constable f. 1808'
768 × 641mm (30¼ × 25¼")
Philadelphia Museum of Art:
John G. Johnson Collection, 1917
(R.08.6)

No information has yet been discovered about Master Crosby, who he was or how Constable came to paint his portrait. The result, however, is among his most engaging pictures of the young. Constable's fondness for children, according to C.R. Leslie, 'exceeded that of any man I ever knew'.[1] This affinity is attested by anecdotes of his kindness and sympathy to his own offspring, and also to his assistant, the younger John Dunthorne, who began to help him as a teenager.

This picture shows evidence of how much Constable had learnt from making copies after Sir Joshua Reynolds and John Hoppner for the Tollemache family. Reynolds, in particular, was renowned for his paintings of children. It is a sign of their popularity that Maria Bicknell – an amateur artist – was engaged in copying two of them, *Puck* and *The Contemplative Boy*, from engravings in 1811–12. She wrote to Constable about the progress she was making.

Like Reynolds's children, Constable's are closely observed individuals. James Northcote, a friend of both men, described Sir Joshua's technique with young sitters: 'He used to romp and play with them, and talk with them in their own way; and, whilst all this was going on, he actually snatched those exquisite touches of expression which make his portraits of children so captivating.'[2]

It looks as if the atmosphere was more restrained in Constable's sittings. Master Crosby seems shy, lost in thought, almost melancholy. His face, beautifully and sensitively painted, is in contrast to the awkwardness of his pose. That inelegance may well have been the result of Constable's lack of skill, but, nonetheless, it is as expressive of childishness as Reynolds's fluent accomplishment.

1 Leslie 1951, p.71.
2 Shawe-Taylor 1990, p.217.

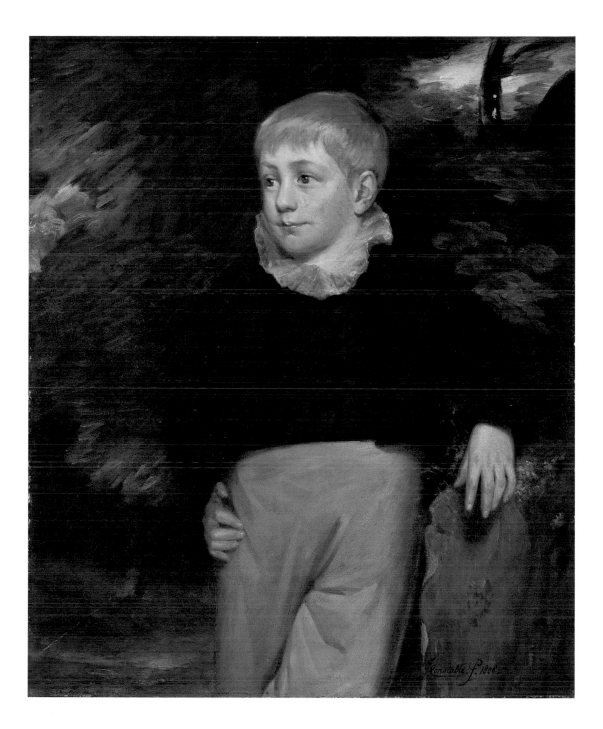

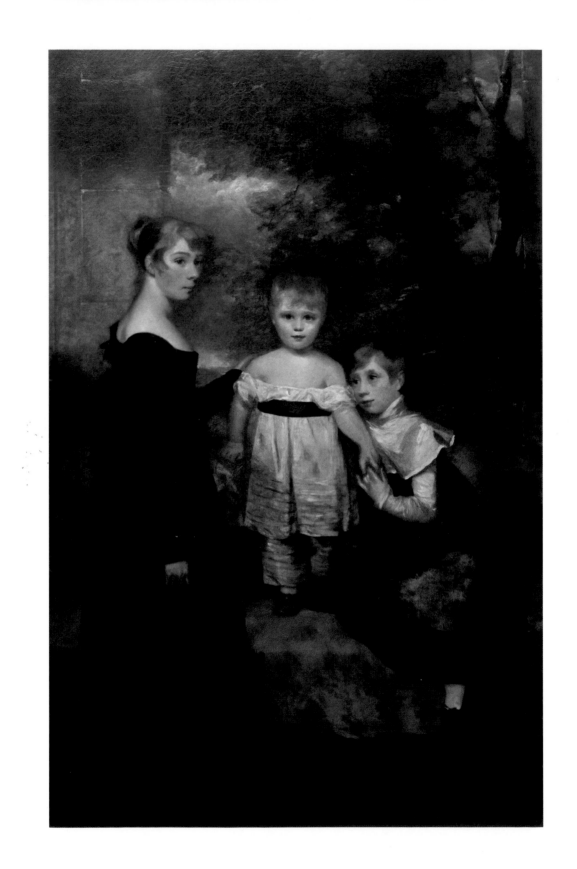

22 The Barker Children

*c.*1809

Oil on canvas, 2045 × 1308mm (80½ × 51½")
Private Collection, Ireland
(R.09.84)

This, the most polished and successful of Constable's group portraits, was unknown to art history until it appeared on the art market in 1987, and it is still not clear exactly how and why he came to paint such a large and ambitious depiction of this family.

The Barkers seem to have been acquainted with his relations the Gubbins family. On a page of the sketchbook he used on his visit to their house at Epsom in 1806, the name 'S.N. Barker' is written. This is the name of the oldest of the three children who stands on the left: Sophia Norris Barker.

She would then have been at least eight, as she was baptized at the church of St Giles, Cripplegate in London, on 30 March 1798. Her younger sister, on the right, is Harriet Sarah Barker, baptized 24 October 1802, and the baby of the family is Robert whose christening was on 13 December 1807. Their apparent ages therefore suggest the picture was painted in 1809.

This date fits with a reference made by Constable's mother, Ann, in a letter of 17 July 1809: 'I also rejoice to hear such a favourable account of Mrs Norris's picture, & that it is nearly completed'.[1] Mrs Constable was often relieved to hear that Constable was getting on with commissions for family and family friends.

Mrs Norris seems to have been on close terms with the Gubbinses of Epsom, since Jane – John Constable's cousin – attended her marriage in Bath in 1810.

It seems possible, therefore, that Mrs Norris ordered the portrait of the Barker children. That she had a significant relation to the children is suggested by the fact that Sophia was given 'Norris' as a second name. But her exact relation to them – aunt, godmother, grandmother – is unknown.

The children, like Master Crosby, seem pensive and shy. Perhaps this is just the consequence of posing. Constable in his portraits tended to paint just what he saw. But the effect is to give the group a touching sense of mutual affection, the two elder sisters seeming quietly protective of their sturdy infant brother.

Constable himself remained in touch with the Barkers. In 1817, he noted to his wife that 'Sophy' Barker had married the eldest son of 'Mr Page'. Together they would have £800 a year, a comfortable income. 'A capital beginning', he commented. Indeed Constable thought the sum was too good: 'It will make the young architect idle'.[2] Constable himself did not have the handicap of superfluous funds.

1 JCC I 1962, p.34.
2 JCC II 1964, p.226 (letter to Maria Bicknell, 5? July 1817).

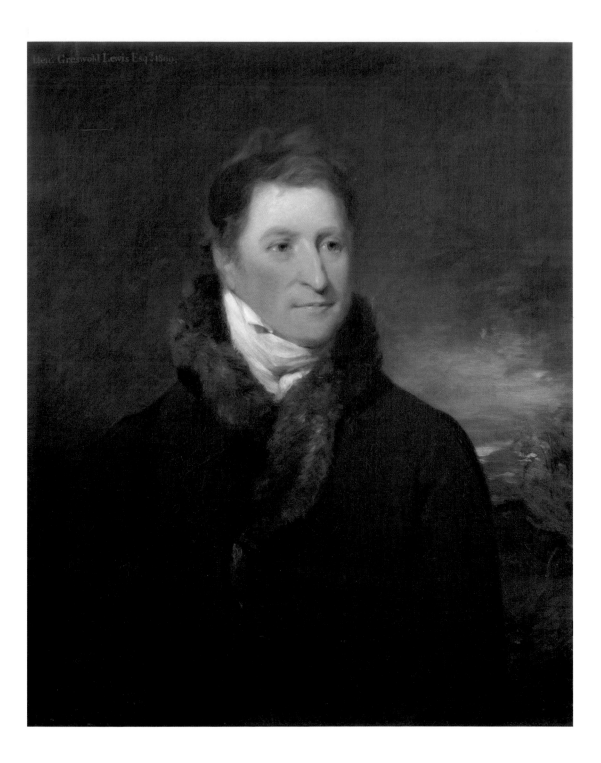

23 Henry Greswold Lewis (1753–1829)

1809

Oil on canvas, 750 × 620mm (29½ × 24⅜")
The Weston Park Foundation
(R.09.25)

Mr Henry Greswold Lewis was an enterprising, but highly eccentric, patron of the arts. He employed both Constable and the architect Sir John Soane (1753–1837) – an impressively acute choice of talents – but it cannot be said that he always used their abilities well. He employed Soane – whom he had met in Italy on the Grand Tour in 1779 – to remodel his country house, Malvern Hall at Solihull, but subsequently had almost all of Soane's modifications reversed, complaining to Constable that the architect was a 'Modern Goth'.[1] He spared, however, a curious barn built in the style of the primitive Doric temples at Paestum.

Some of Lewis's commissions to Constable were equally idiosyncratic, although he also gave more normal orders for copies of his own portrait and a new one of Lewis's relation the Revd George Bridgeman (1813; The Weston Park Foundation; R.13.11).

In 1819, Lewis asked Constable to paint an imaginary portrait of his Norman ancestor, Humphri de Grousewolde, for the staircase at Malvern Hall. This Constable did and – just as surprisingly – in 1829 he produced a sketch of a sign for the Old Mermaid & Greswolde Armes Inn, Solihull, which Lewis owned. A Constable drawing for this of a fish-tailed nude flourishing a mirror still exists (Private Collection; R.29.54).

1 JCC IV 1966, p.62 (letter from H.G. Lewis, 18 April 1819).

24 Mary Freer (b.1796)

1809

Oil on canvas, 762 × 635mm (30 × 25")
Yale Center for British Art
Paul Mellon Collection
(R.09.23)

Henry Greswold Lewis was a widower, his wife having died in 1802, and he was strongly – indeed obsessively – interested in his ward, a young girl named Mary Freer. Having met the painter through the Tollemache family – who were relations by marriage – in 1809 he ordered portraits of himself and his ward, who was then aged thirteen.

Constable travelled to Malvern Hall in late July of that year, and there did a number of drawings and sketches of the house, park and area, plus the finished and masterly *Malvern Hall from the Lake* (plate 25). This landscape was, however, probably not a commission from Lewis who was much more interested in the portraits of himself and Mary Freer. He followed up the latter with a truly bizarre suggestion in a letter to Constable of 19 November 1809.

In a jeweller's shop on Bond Street in London he had seen a strange item, a tiny painting on ivory for a ring or brooch of 'the human eye & enough of the forehead to know the likeness'.[1] Could, he wondered, Constable paint Mary Freer's eye for a shirt-pin? No such shirt-pin survives, and it seems unlikely Constable ever undertook this task.

1 JCC IV 1966, p.50.

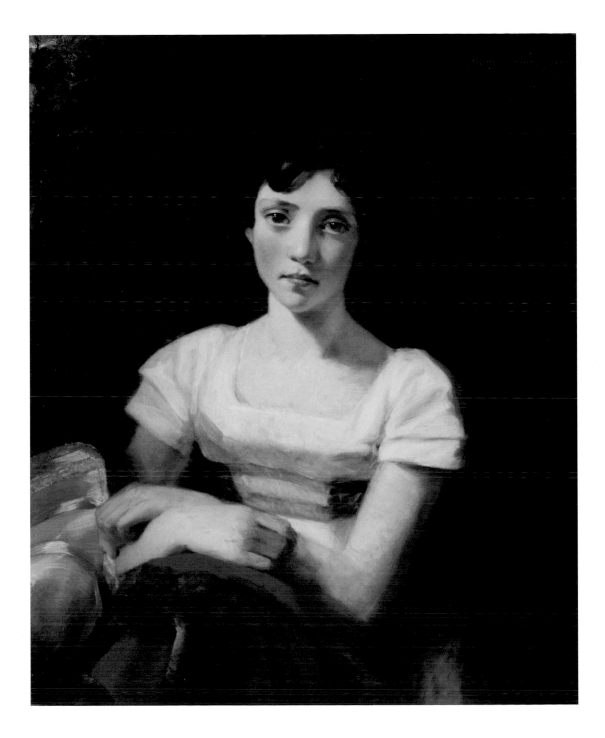

25 Malvern Hall from the Lake

1809

Oil on canvas, dated '1 August 1809' in inscription
recorded in 1840, 514 × 768mm (20¼ × 30¼")
Tate. Bequeathed by George Salting 1910
(R.09.17)

Romance and Marriage

26 Maria Bicknell (1788–1828)

c.1805–9

Pencil on paper, inscribed in a later hand 'Mrs J.C.'
488 × 348mm (19¼ × 13¾")
Tate. Purchased 1984
(R.09.82)

Maria Bicknell was the love of Constable's life, her only rival in his affections being the landscape of East Bergholt and the profession of painting. Their romance, however, was fraught and protracted because of the opposition of her family – and especially of her grandfather, the Rector of East Bergholt-cum-Brantham, the Revd Dr Durand Rhudde.

Constable states in a later letter that he pledged his love for her in 1809 – though according to Leslie they had met as early as 1800, when she was twelve.[1] This drawing, if it is of her – the identification is not quite certain – was perhaps done at the time of his declaration in 1809. Constable's uninvited visit to Spring Grove, Bewdley, in December 1811 – where Maria was staying with her half-sister, Sarah Skey – provided another opportunity for a sitting.

1 Leslie 1951, p.25.

p.108: plate 27 (detail)

27 Maria Bicknell

1816

Oil on canvas, inscribed by the artist with brush
above sitter's left shoulder 'July. 10 1816'
305 × 251mm (12 × 9⅞")
Tate. Bequeathed by George Salting 1910
(R.16.13)

This portrait was painted under much more
propitious circumstances than the earlier drawing.
At last, there was a real prospect of Constable
and Maria's marriage. On 14 May 1816, Golding
Constable had died after a long illness. The arrange-
ments of his will guaranteed Constable just sufficient
income for him to make up his mind to marry Maria.
On 3 July, he called on his friend and mentor Joseph
Farington, and stated that he had decided to do so,
'witht. Further delay & to take the chance of what
might arise'.[1]

This painting must have been begun shortly
afterwards, during a period in which the couple were
able to meet with unusual ease. It is dated 10 July, and
thus in effect is an engagement picture. Constable
took it with him when he went to East Bergholt on
16 July. In the following months, he mentions the
portrait on a number of occasions.

He calls it 'This sweet remembrancer of one so
dear', slightly misquoting *On The Receipt of My Mother's
Picture* by William Cowper (a favourite poet of Maria's).
It caused 'no small sensation' at a village party. Its
'extreme' likeness to the sitter was remarked on.[2]

On 16 August, he wrote, 'I would not be without
your portrait for the world. The sight of it soon calms
my spirit under all trouble and it is always the first
thing I see in the morning and the last at night.'[3]
This is, then, a picture painted with love that became,
for a while, a surrogate for the loved one.

1 Farington, *Diary*, vol.XIV, p.4866.
2 JCC II 1964, p.189 (letter to Maria Bicknell, 28 July 1816).
3 Ibid., p.195 (letter to Maria Bicknell, 16 August 1816).

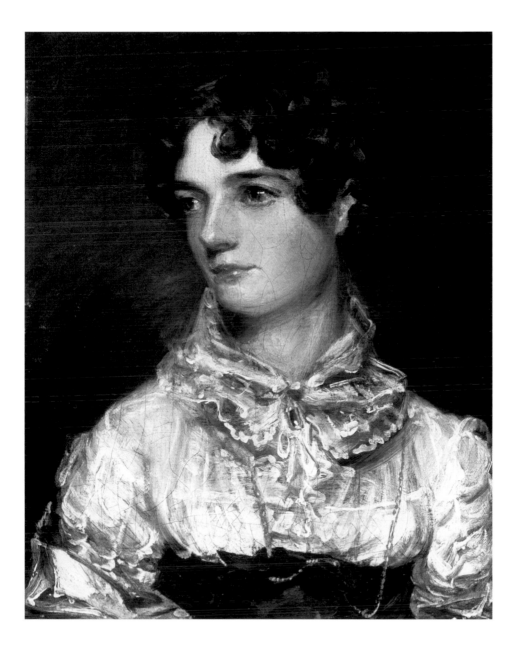

28 The Rectory from East Bergholt House

1810

Oil on canvas laid on panel, inscribed by the artist with
brush on right edge '30 Sep / 1810 / E. Bergholt / Common'
156 × 248mm (6⅛ × 9¾")
Philadelphia Museum of Art:
John G. Johnson Collection, 1917
(R.10.5)

On 22 June 1812, Constable wrote to Maria Bicknell from East Bergholt:

> From the window where I am writing I see all those sweet feilds [*sic*] where we have passed so many happy hours together. It is with a melancholy pleasure that I revisit those scenes that once saw us so happy – yet it is gratifying to me to think that the scenes of my boyish days should have witnessed by far the most affecting event of my life.[1]

That 'affecting event' was his declaration of love and Maria's response to his avowal. This landscape sketch was painted in the early autumn of 1810, looking out at precisely the view he described in the letter – presumably the prospect from his own room in the Constable family house where he wrote letters and also sometimes painted.

In the centre of this dawn landscape, nestling behind the trees of a small wood, is the Rectory, the home of Maria's grandparents – the place where she stayed when visiting East Bergholt. It is hard, therefore, not to see this little landscape – with a blushing pink sky and painted around the anniversary of that 'most affecting event' – as suffused with emotion.

1 JCC II 1964, p.78.

Revd John and Mary Fisher

(ILLUSTRATED OVERLEAF)

John Fisher was Constable's closest friend and recipient of his most eloquent letters on the subject of art (the letters to Maria are naturally more heartfelt on the subject of love). He was the nephew of the Bishop of Salisbury and an old friend of the artist. Their friendship took 'so deep a root' – as the painter put it – on Constable's visit to Salisbury in the early autumn of 1811.[1]

Over the next few years, they continued to see each other, and a boisterous, joshing correspondence developed between the two men. Although the younger Fisher was twelve years Constable's junior, they had shared interests in landscape painting, Latin verse, a faith in Anglican Christianity and a love of country walks.

Crucial to their bond no doubt was Fisher's admiration for Constable's art. He wrote that his friend's main exhibit at the Royal Academy exhibition of 1813 was exceeded only by J.M.W. Turner's *Frosty Morning* (Tate). But, he went on, 'you need not repine at this decision of mine, you are a great man like Bonaparte & are only beat by a Frost'.[2]

John Fisher was ordained in May 1812 and the following year his uncle gave him the living of Osmington, a village on the Dorset coast near Weymouth. This provided him with an income of £800 a year, easily enough on which to marry. In 1816, he married Mary Cookson, then twenty-five, the daughter of Dr William Cookson, Canon of Windsor. Her father was an old friend of Bishop Fisher's and of Constable's mentor, Joseph Farington. The poet William Wordsworth was her cousin.

The wedding took place on 2 July, solemnized by Bishop Fisher, and evidently impelled Constable's decision to marry Maria. It was the next day that he told Farington he would do so 'witht. Further delay'.

There was, however, more delay while Maria wondered whether they should wait longer, and Constable got side-tracked into painting projects. Eventually, Fisher bounced them to the altar, writing on 27 August that he would be arriving in London on Tuesday 24 September, 'And on Wednesday shall hold myself ready & happy to marry you. There you see I have used no roundabout phrases; but said the thing at once in good plain English.'[3] In fact, after some last-minute confusion, Fisher married them at the church of St Martin-in-the-Fields, London, on 2 October.

1 JCC VI 1968, p.207 (letter to John Fisher, 12 November 1825).
2 Ibid., p.21 (letter from John Fisher, 14 June 1813).
3 Ibid., p.28 (letter from John Fisher, 27 August 1816).

29 Revd John Fisher (1788–1832)

1816

Oil on canvas, 359 × 305mm (14⅛ × 12″)
The Fitzwilliam Museum, Cambridge
(R.17.3)

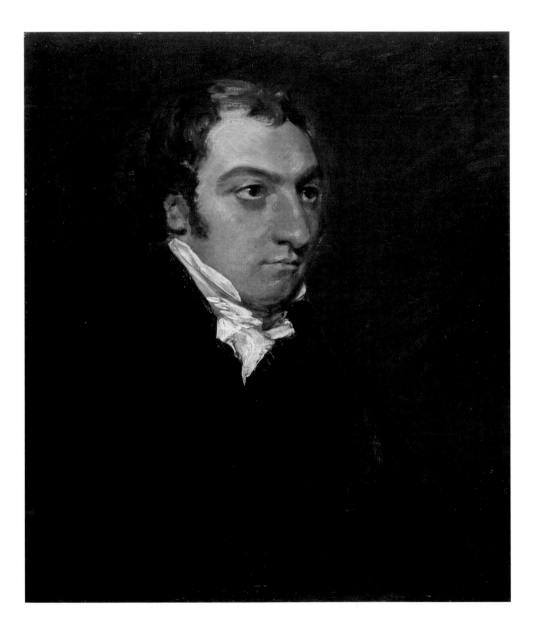

30 Mary Fisher (b.1797)

1816

Oil on canvas, 359 × 305mm (14⅛ × 12")
The Fitzwilliam Museum, Cambridge
(R.16.83)

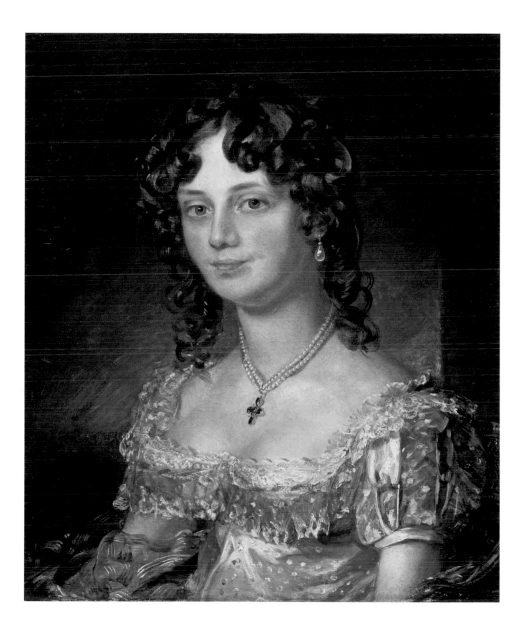

31 Osmington Village

1816

Oil on canvas, 257 × 305mm (10⅛ × 12″)
Yale Center for British Art
Paul Mellon Collection
(R.16.58)

John Fisher's letter of 27 August 1816 also suggested that the newly wed couple should visit him at Osmington afterwards for a honeymoon. 'The country here is wonderfully wild & sublime & well worth a painters visit. My house commands a singularly beautiful view: & you may study from my very windows. You shall [have] a plate of meat set by the side of your easel without your sitting down to dinner: we never see company: & I have brushes paints & canvass [sic] in abundance. My wife is quiet & silent & sits & reads without disturbing a soul & Mrs. Constable may follow her example.'[1]

This, though it sounds a little quiet from the bride's point of view, is what they did. First they went to Southampton – they discussed the extravagance of going by post-chaise. On 11 October, they visited the medieval ruins of Netley Abbey on the outskirts of the town. Next they went on to Osmington, where they stayed with John and Mary Fisher for six weeks. A late autumn holiday beside the sea was not as eccentric as it seems today. Four years earlier, Maria herself had prolonged a stay at Bognor and Brighton until December.

Constable, as Fisher had suggested, busied himself with painting. In a month and a half, he produced numerous drawings, studies of the coast, the portrait of Mary (plate 30), and this view of the village itself. The vicarage where the Fishers lived and the Constables were staying is the building to the left of the church from the chimney of which smoke is rising. As Fisher later spent £600 on enlarging the house, the four newly weds were probably quite cramped for space.

The way that Fisher and Constable spent their time was doubtless much as Fisher had earlier proposed for a suggested stay in Salisbury (though it was late in the season for swimming). 'We will rise with the sun, breakfast & then out for the rest of the day – if we tire of drawing we can read or bathe & then home at nightfall to a *short* dinner.' If, as Fisher put it with an angling metaphor, the maggot so bit, they could 'puzzle out a passage or two in Horace together'.[2] The Constables stayed with Mary Fisher's parents at Binfield in Berkshire on their return journey, arriving back in London on 9 December.

1 JCC VI 1968, p.29.
2 Ibid., p.15 (letter from John Fisher, 8 May 1813).

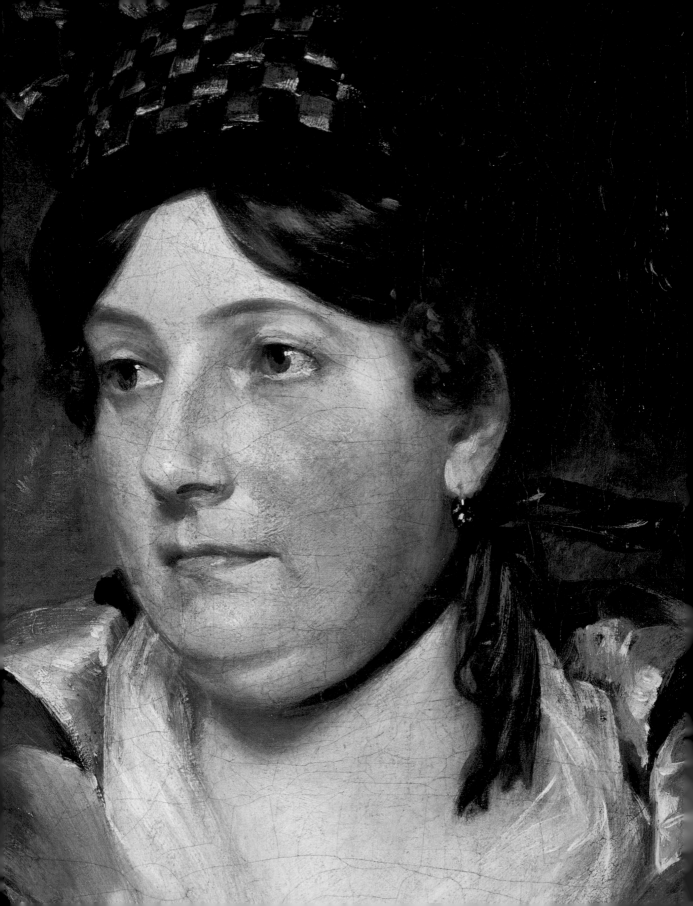

Mature Portraits

32 Mrs James Pulham Snr (c.1766–1856)

1818

Oil on canvas, 756 × 629mm (29¾ × 24¾")
The Metropolitan Museum of Art
Gift of George A. Hearn, 1906
(R.18.8)

This is one of Constable's finest achievements as a portrait painter: truthful, anything but flattering, yet dignified and sympathetic. The sitter is lost in thought – perhaps the effect of posing – and evokes sympathy despite or because of her slightly ridiculous best clothes. At one point, it was thought that she was wearing costume of c.1830, until it was realized that her substantial bosom had been mistaken for puff-sleeves.

Mrs James Pulham, née Frances Amys, was about fifty-two at the time of the portrait. She was an amateur painter and the wife of James Pulham, a successful solicitor practising in Woodbridge, who was both a friend and a patron of Constable's. The Pulhams had interests and contacts in common with the painter. The Pulhams' son, James Brook Pulham, was married to the daughter of Pierre Noël Violet (1749–1819), a French émigré miniature painter who lived, like Constable, on Charlotte Street.

The lives of Constable and the Pulhams criss-crossed in other places. James Pulham was a friend of Constable's patron, Henry Greswold Lewis, who he probably met through the Tollemache circle at Helmingham. Their daughter (also called Frances Pulham) married Harcourt Firmin of Dedham, a member of a family often mentioned in the Constable family letters (though Harcourt himself was heartily disliked by Abram Constable).

It is not surprising, then, that the like-minded Pulhams became enthusiastic collectors of Constable's work. James Pulham was encouraging him to paint the portrait of an unnamed elderly clergyman at the very moment in September 1816 when Constable was about to get married (the commission threatened to delay the ceremony). In addition to this picture, there was perhaps a pendant Constable portrait of James Pulham himself – oils of both were bequeathed by the Pulhams' daughter-in-law, Maria – which has disappeared. Pulham also acquired several important landscapes including 'a nice little coast' – probably *Harwich Lighthouse* (1820; R.20.6) – and *Helmingham Dell* (1826; Philadelphia Museum of Art; R.26.21).

p.120: plate 32 (detail)

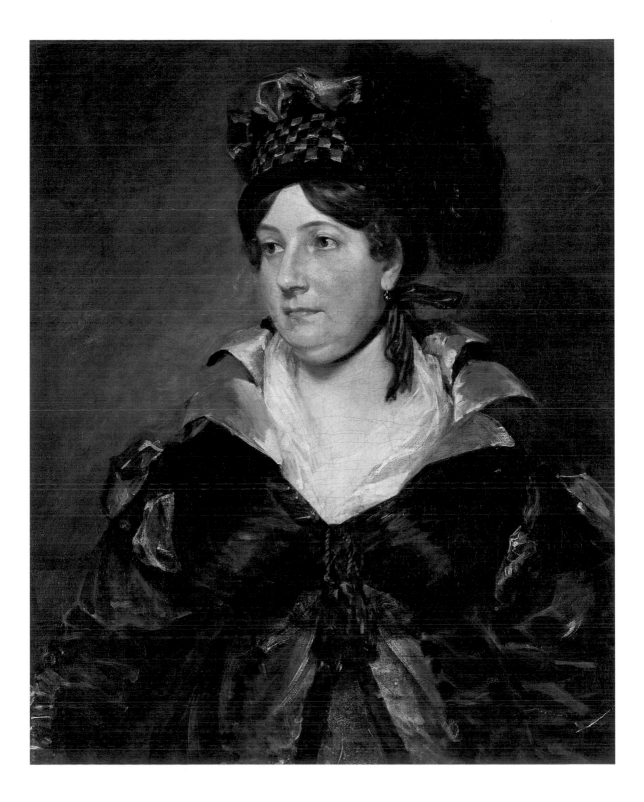

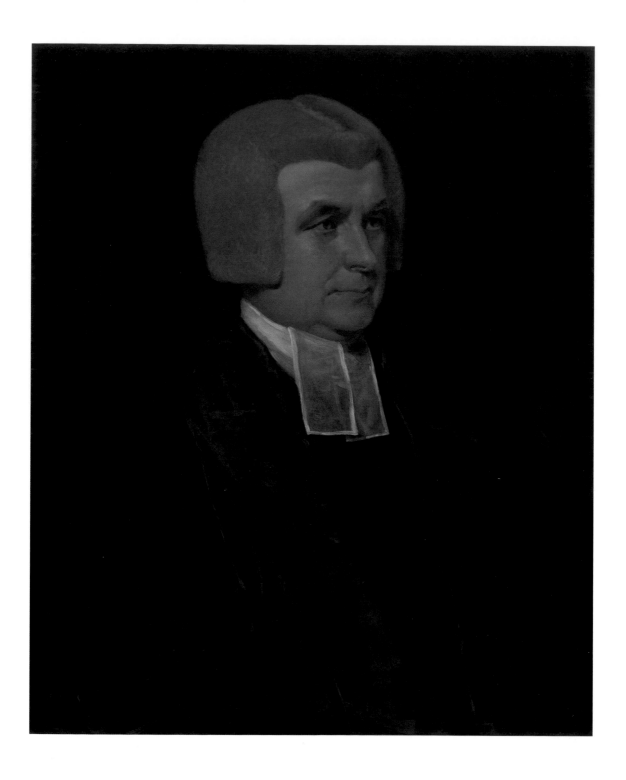

33 Revd Dr John Wingfield (1760–1825)

1818

Oil on canvas, signed 'Jon. Constable. Pinxt. 1818.'
762 × 637mm (30 × 25⅛")
Private Collection
(R.18.9)

There were several reasons why Constable might not have taken to Dr Wingfield. The first of these was that the clergyman spent over twenty years, from 1781 to 1802, as a master at Westminster School. Constable had extremely mixed feelings about teachers. He had been flogged at his first school, in Lavenham, with the result, according to C.R. Leslie, that he secretly resolved to pay the usher responsible 'back in kind'. This was, Leslie went on, 'a resolution he was well qualified to put in practice, unless the usher had been a man of uncommon physical strength'.[1]

When the engraving by W.J. Ward after this portrait was published in 1826, it sold well enough only to cover costs. 'No one will buy a *schoolmaster*', Constable commented in a letter to Fisher. 'Who would buy the keeper of a tread mill, or a turnkey of Newgate, who has been in either place?'[2] Indeed, the poet Robert Southey (1774–1843), who was a pupil at Westminster, considered Wingfield a man 'with no qualities at all'.[3]

Nor did the painter have a high opinion of the occupants of cathedral closes, who he considered 'drones'. And Wingfield, after a scant three months

as Headmaster of Westminster, left to become a prebendary of Worcester Cathedral and absentee holder of a number of livings.

Nonetheless, the evidence of the painting is that Constable found his sitter congenial. It is not only one of his most accomplished male portraits, but also pleased Bishop Fisher and his daughter Dolly who inspected it in the studio. 'There is a playfulness in the eye of Dr Wingfield', Dolly Fisher wrote to Constable, 'which pleases me extremely'.[4]

It is not clear how the sitter came to be in touch with Constable, but there are several possibilities. He was the Vicar of Bromsgrove among several parishes, which brought him into the vicinity of H.G. Lewis at Malvern Hall, Solihull, and Maria's half-sister, Sarah Skey (later Fletcher) at Bewdley. Both of these were likely to recommend Constable's services. Moreover, Wingfield's brother-in-law J.T. James, later Bishop of Calcutta, had been a star pupil at Charterhouse at the time when Dr Philip Fisher – brother of Bishop Fisher and father of the younger John Fisher – was Master of the school.

1 Leslie 1951, p.2.
2 JCC VI 1968, p.231 (letter to John Fisher, 26 August 1827).
3 J. Sargeaunt, *Annals of Westminster School* (London, 1898), p.211.
4 JCC VI 1968, p.37 (letter from Dolly Fisher, ?1818).

34 Mrs Tuder (1760–1840)

*c.*1818

Oil on canvas, 748 × 622mm (29½ × 24½")
Barnsley MBC Museum Service
Cannon Hall Museum
(R.18.11)

These portraits of a mother and daughter (see plate 35) are part of a trio of pictures representing an extended family group – the third being a depiction of the Revd Dr William Walker painted by Constable at the same time (see p.26). Together, they amount to a remarkable depiction of a class not well represented in British portraiture: the pious, respectable and prosperous bourgeoisie. This was the sort of society from which Constable came and he depicts its members with splendid truthfulness.

New research has established that Mrs Tuder's full name was Elizabeth Camilla Tuder, and her maiden name was Walker. She was married to Revd William Tuder (d.1820), who was Rector of the parish of Kingston Seymour in Somerset, and died, at the age of eighty, in 1840.

Revd Walker was Rector of Layham, a parish in Suffolk not far from East Bergholt. The Walker family, however, apparently came from Putney, London. That was noted as Elizabeth Camilla's address at the time of her marriage and also as the home of William Walker in the will of Ann Cam, their cousin, in 1790.[1]

Constable's commission, therefore, was to paint the portraits of a brother, sister and her daughter. Why these particular members of the family were singled out is not clear; a possible explanation is that all three were in London simultaneously. The Tuders were evidently proud of the Walker connection. In 1826, Captain Tuder – Mrs Tuder's eldest son, William – paid Constable £30 to cover the costs of the engraving of Revd Walker's portrait by William Ward.[2] John Kelly Tuder, her second son, lived at 'Walker Cottage', Manorbier, on the coast near Tenby.[3] These three portraits remained in the possession of John Kelly Tuder's descendants until 1953, when they were sold and separated.

1 For Ann Cam's will, see *Gentleman's Magazine*, May 1790, p.473. Elizabeth Camilla Tuder and Revd William Walker, named as cousins, were both legatees, also her 'Aunt Walker'. The latter was presumably the Elizabeth Walker who gave consent for her daughter, Elizabeth Camilla – a minor, of Putney – to marry Revd William Tuder at St George's, Hanover Square. Revd Walker is named as a trustee in the will of Harriot Tuder, Mrs Tuder's daughter-in-law. The marriage of Elizabeth Camilla Tuder and Cadwallader Edwards was registered in Tenby in 1811 (Narberth Hundred Records).

2 JCC II 1964, p.430 (Constable's journal, 22 May 1826). Captain William Tuder married Harriot Cole at Tenby on 13 February 1817.

3 Will of John Kelly Tuder, Public Records Office.

35 Mrs Edwards (d.1860)

*c.*1818

Oil on canvas, 760 × 635mm (29⅞ × 25″)
Museum of Art, Rhode Island School of Design
Corporate Membership Fund
(R.18.12)

This is the second of three family portraits Constable
executed for the Tuder/Walker family in 1818. Mrs
Tuder's daughter – also named Elizabeth Camilla –
married a Mr Cadwallader Edwards in Tenby in 1811,
that area of Pembrokeshire apparently being the
ancestral home of the Tuder family.[1] This gentleman
with a very Welsh name lived at Ballyhire, County
Wexford, on the extreme south-eastern promontory
of southern Ireland.

1 The Christian names of Mrs Tuder, Elizabeth Camilla, and of
her daughter – which were the same – are both given in her will
(Public Records Office).

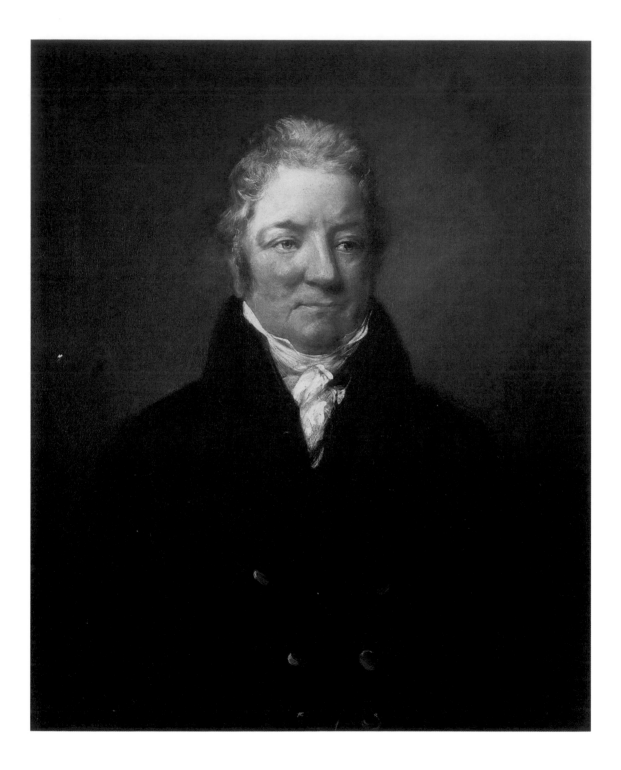

36 William Lambert JP (1761–1838)

1825

Oil on canvas, 750 × 622mm (29½ × 24½")
Private Collection
(R.25.14)

As Constable explained to his friend John Fisher, William Lambert JP of Shortes Place, Woodmansterne in Surrey, was a 'very old friend' of his father-in-law, Charles Bicknell. Maria Bicknell went to stay with the Lamberts in 1815, the year before her marriage to Constable, and remarked on Miss Jane Lambert's patience despite the fact that her stepmother, William Lambert's second wife, was 'tiresome'.[1]

In view of this old friendship, Constable was not in a position to refuse a portrait commission from the Lamberts in 1825. He confessed to Fisher, 'I left home most unwillingly to do this job, but it is my wife's connection and I thought it prudent to put a good face on it.'[2]

William Lambert's son, also called William, was a member of the Bengal Civil Service and lived with his family in Calcutta. His three children, however, had returned to stay with their grandparents in Surrey and be educated in England. The first proposal was that Constable should paint the three children with their grandfather and the picture be sent to their parents in India.

But it was decided that this arrangement would cause William Lambert senior to 'lose his countenance and look sadly like a schoolmaster with his pupils'.[3] Therefore, it was decided that the children should be painted with a donkey, the idea coming from Maria's old friend Jane Lambert. This made 'a pretty picture' Constable assured Fisher, though in fact the result was awkward.

William Lambert was painted in February 1825 in Constable's London painting room as 'a usual size three-quarters' at a fee of 50 guineas.[4] Although Constable was not on particularly friendly terms with Lambert, he was interested and amused by him. His description, to Fisher, was vivid: 'Mr Lambert is the old Country Esqre. His "study" contains pictures of racers & hunters – guns, gaiters, gloves, half-pence, turnscrews, tow, gunflints &c &c.'[5]

Constable wrote in a letter to Maria that Lambert had just come in from the hunt, and that he was tempted to watch him arrive with the hounds and hunters.[6] The resulting picture could be of a character from Surtees.

1 JCC II 1964, p.154 (letter from Maria Bicknell, 2 October 1815).
2 JCC VI 1968, p.191 (letter to John Fisher, 23 January 1825).
3 JCC II 1964 p.372.
4 Reynolds 1984, no.25.14, p.160. For further discussion of this fee, see also p.45 and note 51 on p.57.
5 JCC VI 1968, p.192 (letter to John Fisher, 23 January 1825).
6 JCC II 1964, p.376 (letter to Maria Bicknell, 25 January 1825).

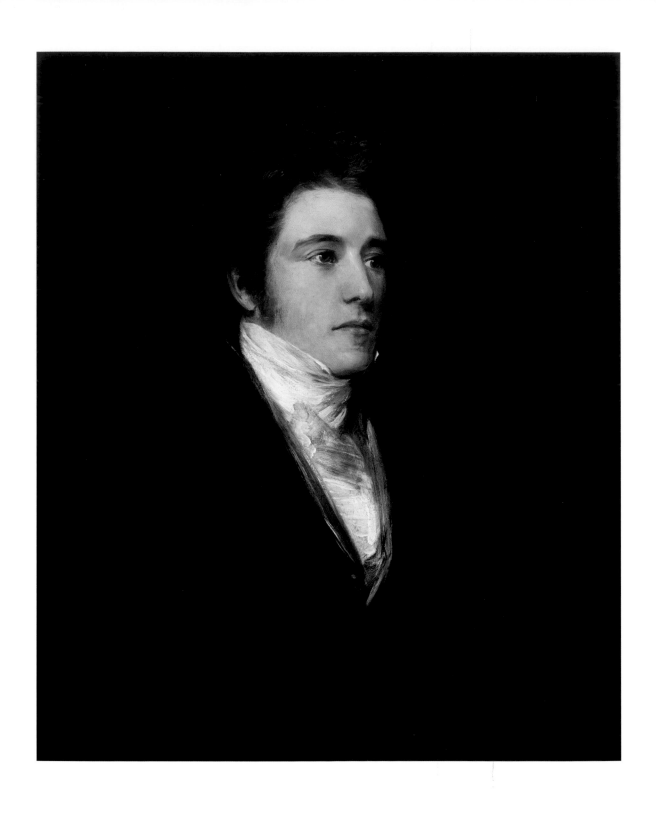

37 Sir Richard Digby Neave, Bt (1798–1868)

1825

Oil on canvas, inscribed on back of canvas
'Digby Neave Esqre Constable pinxt. 1825.'
737 × 610mm (29 × 24")
Private Collection
(R.25.29)

Richard Digby Neave was, as far as Constable was concerned, a most congenial spirit. On 25 June 1824, the painter noted in his journal that 'Mr Neave called this evening about five. He is always the most agreeable person in the world.' On this occasion, Neave was 'astonished' by the landscape on Constable's easel, *Stratford Mill* (National Gallery, London), and hoped the painter would always keep to the scenes in which Constable was 'so entirely original'.[1] He could scarcely have said anything more calculated to please.

At that time, he and Constable had already known each other for several years and Neave may – it seems – have taken informal lessons from him in painting. In an undated letter, Neave presented his compliments to the artist, 'and thinks himself extremely fortunate in having been recommended to apply for Mr Constable's instructions'.[2] Though he did not take pupils formally, Constable sometimes gave help to friends such as Bishop Fisher's daughter Dolly. Constable wrote to Maria that Neave called on 21 May 1819 and was to call again the following day, which suggests a course of study.[3] Eventually, Neave exhibited at the Royal Academy, and two of his landscapes were engraved –

probably at Constable's instigation – by the engraver of Constable's own work David Lucas (1802–81).

Neave was the son of Sir Thomas Neave, Bt, of Dagham Park, Essex; his grandfather, Sir Richard, had been a Governor of the Bank of England. He lived himself at Pitt Place, Epsom, where he was an acquaintance of Constable's cousin Colonel Richard Gubbins. In 1848, he succeeded to the baronetcy.

Relations between Constable and Neave remained highly cordial. In 1825, the year of this portrait, Neave became the godfather to Constable's daughter Emily (presenting her with a gold thimble).

In September 1831, Constable stayed with Neave at Epsom – sleeping in a haunted room – and painted a watercolour of the house (R.31.14). He also seems to have given more painting tips, since Neave wrote saying that he was resolved to find an ash tree such as Constable had depicted both bare in winter and covered with spring foliage.

This portrait of the dashing young gentleman amateur painter conveys the warm sympathy between the two men. Predictably, its pair, of Neave's brother, Sheffield – not a friend of Constable's – is less sparkling (R.25.30).

1 JCC II 1964, p.344.
2 FDC 1975, p.160.
3 JCC II 1964, p.248 (letter to Maria Bicknell, 21 May 1819).

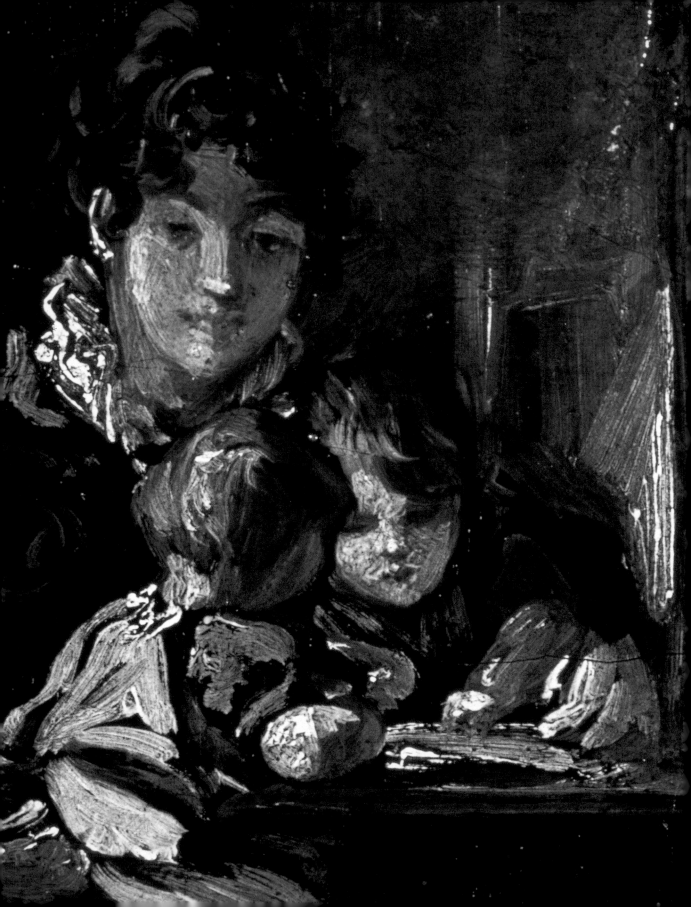

Family Life

38 Maria Constable with Two of Her Children

*c.*1820

Oil on panel, 165 × 215mm (6½ × 8½")
Tate. Purchased 1984
(R.20.86)

Constable was an enormously proud and fond father. After a miscarriage, Maria gave birth to their first child – a boy, named John Charles after his father and grandfather, Charles Bicknell – on 4 December 1817. The painter called him 'our darling Duck' – he was prone to give affectionate nicknames drawn from river-life, calling Maria 'Fish'.

'Kiss my darling a thousand times', he wrote to Maria from East Bergholt on 9 May 1819, 'call him my boy, my lovely boy, my darling Duck and tell him it is all from me – his father who is always talking about him'.[1] A couple of months later, on 9 July, a daughter – christened Maria Louisa, after her mother and aunt Louisa Bicknell, and shortened to Minna – followed. 'A more lovely little girl at a month old was never seen', in Constable's opinion.[2] It is hard to believe that the infant in the drawing from October 1819 is any other than the four-month-old Minna (plate 40).

The wonderfully impromptu little sketch of Maria with two children (plate 38) was done on the back of a panel in the style of the seventeenth-century Flemish artist David Teniers (1610–90) – snatched up, perhaps, on the spur of the moment. If the children are the two oldest it was probably done in late 1820 or early 1821 when John Charles would have been about three, and Minna eighteen months. In that case, the location would have been the Constable's London house on Keppel Street, near the British Museum.

A second son, named Charles Golding in honour of both grandfathers, was born on 29 March 1821. On 4 August of that year, Constable wrote to John Fisher from Hampstead, 'I am here as much as possible with my dear family. My placid and contented companion with her three infants are well.'[3]

The unfinished family group (plate 39) exactly reflects this description. It seems from Charles Golding's apparent age – between a year and eighteen months – to date from about a year later. Subsequently, Constable began – but did not complete – yet another family group with four children, but the work is currently untraced (see p.49).

1 JCC II 1964, p.247.
2 JCC VI 1968, p.47 (letter to John Fisher, 13 August 1819).
3 Ibid., p.71.

p.134: plate 38 (detail)

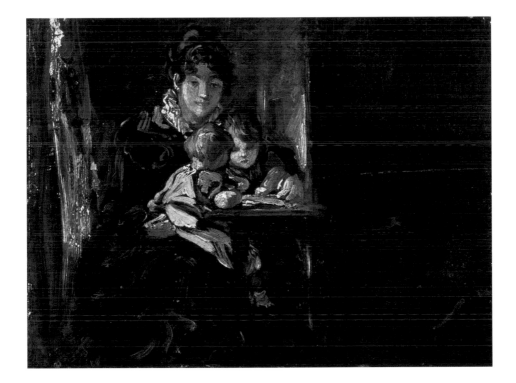

39 Maria Constable with Three of Her Children

*c.*1822

Oil on canvas with pencil underdrawing
355 × 295mm (14 × 11⅝")
Private Collection
(R.22.67)

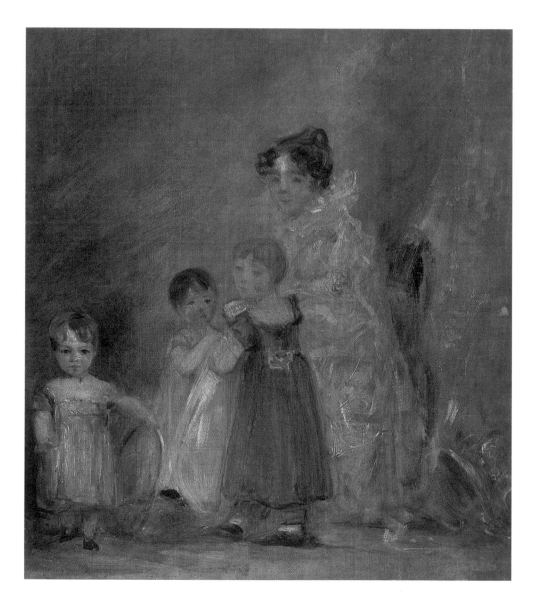

40 A Baby, Perhaps Maria Louisa Constable

1819

Pencil on paper, inscribed by the artist on back
'[H]ampstead […] Octr. 1819'
59 × 105mm (2⅜ × 4⅛")
Victoria and Albert Museum:
Given by Isabel Constable
(R.19.33)

41 View in a Garden at Hampstead

c.1821

Oil on canvas, 355 × 305mm (14 × 12″)
Victoria and Albert Museum:
Given by Isabel Constable
(R.21.104)

From August 1819, Constable was in the habit of renting accommodation in Hampstead during the summer months for the good of Maria's health (before her marriage she had usually spent the summer out of London in Putney or Richmond). In 1821 and 1822, he took a house at No.2 Lower Terrace, Hampstead. There he arranged a makeshift studio in the garden, as he explained to Fisher: 'I have [sundry] small works going on – for which purpose I have cleared a small shed in the garden, which held coal, mops & brooms & that is literally a coal-hole, & have made it a workshop and a place of refuge.'[1]

During these years, Constable painted large numbers of small outdoor oil sketches, including many of his sky studies and others of scenes around Hampstead. There is also a smaller group of domestic landscapes, including two that seem to depict the garden and shed/studio at Lower Terrace. This one, with washing on the line, has been identified as showing the view looking towards Upper Terrace.

There are also three sketches of figures in a garden – the painterly equivalent of family snaps – which belong to this period. One shows a woman with a parasol (see p.27), the second depicts a blond boy with a toy cart and the same woman – presumably Maria – in the background (see p.17). The third newly identified picture (plate 43) shows a young child offering a cat a saucer of milk. The toddler is fair-haired, as Charles Golding seems to have been, and perhaps also John Charles when young. Minna is a brunette in both family groups. Looking at these, one has the impression that the painter has grabbed brush and paints to record a fleeting moment of family life.

The *Study of Tree Trunks, with a Figure Beside Them* (plate 42) combines landscape and figure – not in the garden, but perhaps not far away. The paper support was one Constable used frequently in 1821. The baby might be Charles Golding, born in March of that year, and the woman either Maria or Mrs Roberts the Constables' nurse.

1 JCC VI 1968, p.71 (letter to John Fisher, 4 August 1821).

141

42 Study of Tree Trunks, with a Figure Beside Them

*c.*1821

Oil on paper, 248 × 292mm (9¾ × 11½")
Victoria and Albert Museum:
Given by Isabel Constable
(R.21.114)

43 Child in a Garden, Probably the Young John Charles Constable (1817–41) or Charles Golding Constable (1821–79)

*c.*1821–3

Oil on board, 289 × 245mm (11⅜ × 10")
Private Collection, Paris

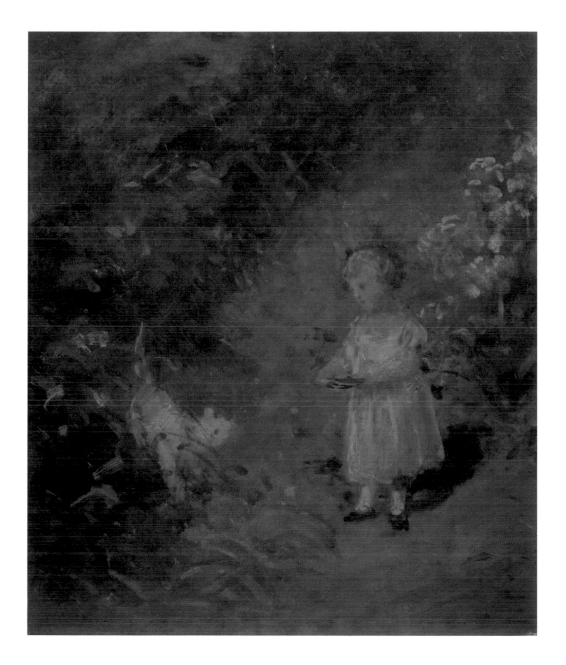

44 Dr Herbert Evans

?1829

Oil on canvas, inscribed 'John Constable A.R.A.'
and dated indistinctly ?'1829'
305 × 250mm (12 × 9⅞")
Private Collection
(R.29.53)

Herbert Evans was not only Constable's family doctor, but also a friend and an admirer of his work – naturally a highly appealing combination to the artist. On 4 July 1829 – around the time that this portrait was painted – Evans accompanied Constable to the Royal Academy exhibition. The painter described this visit in a letter to John Fisher. Evans was impressed by Constable's *Hadleigh Castle* (1829; Yale Center for British Art) and was 'horrified at the violence done to all natural feeling in *Turner*' (who exhibited three works that year, including *Ulysses deriding Polyphemus* (1829; National Gallery, London)). Evans's 'intellect & cultivation', Constable told Fisher, were 'of the first class, & his integrity invulnerable'.[1]

Evans and Constable had met in 1827 and, given the frequent illnesses of the Constable household and Maria's chronic sufferings from tuberculosis, sadly there was frequent reason for Dr Evans to call. The young doctor continued to minister to the family after Maria's death in November 1828, and there are many references to him and his advice in the painter's letters to C.R. Leslie. Indeed, Constable depended on him. 'He is a skilful, & honest doctor', he wrote to Leslie in January 1832, 'a very sensible man – with great acquirements and a most sincere friend – so that I have *many* blessings – yet.'[2] Constable attended Evans's wedding breakfast later in the year, observing 'no man deserves more happiness'.[3]

The date of 1829 on this portrait is slightly puzzling, since Constable was elected a full Royal Academician on 10 February of that year, and the signature is 'John Constable A.R.A.' – or Associate Royal Academician. Constable also painted a portrait of Evans's mother, which was 'just done' by 4 July 1829, and she mentions that her picture 'is to be the same size as Herbert's' – so his picture was evidently done earlier.[4] Perhaps the picture was completed in the first six weeks of the year, when Constable was still an ARA – and very shortly after Maria's death.

1 JCC VI 1968, p.248 (letter to John Fisher, 4 July 1829).
2 JCC III 1965, p.57.
3 Ibid., p.75 (letter to C.R. Leslie, 8 July 1832).
4 JCC VI 1968, p.248 (letter to John Fisher, 4 July 1829).

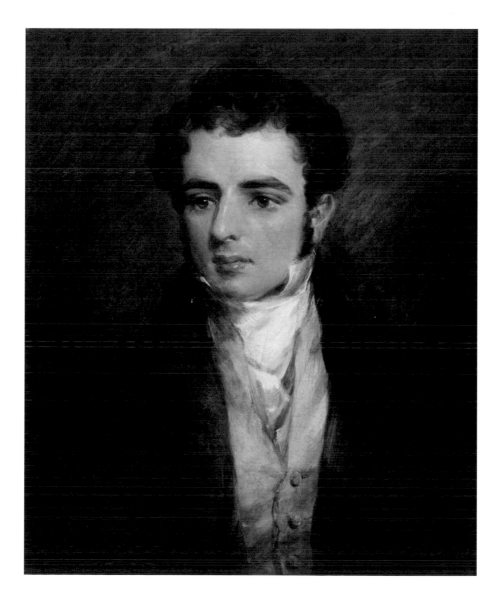

45 Emily (1825–39) on a Sofa

1834

Pen and ink on writing paper laid on card
107 × 182mm (4¼ × 7⅛")
The Samuel Courtauld Trust
The Courtauld Gallery, London
(R.34.11)

This drawing is inscribed on the back of the mount –
but not by the artist – as 'Emily lying on the sofa' on
the afternoon of Sunday 11 May 1834. The location is
given as Well Walk, Hampstead, where the Constables
took a house from 1827. Another note on the front
of the sheet, also in another hand, gives the date as
11 May.

Assuming these notes are based on Constable's
own (one of them slightly inaccurate) on the back of
the paper, this lively sketch is another of his quick
notations of family life – just a few lines jotted down
on a sheet of writing paper, perhaps as Constable was
busy with his correspondence. It demonstrates that,
nearly twenty years after he had drawn Joshua Hobson
reading at a window (plate 18), Constable still had the
knack of catching mood and posture.

Emily was the fifth of the Constables' children and
the third of their daughters. At the time of this sketch
she was nine; she died of scarlet fever at fourteen, two
years after her father.

May 18 1834 — Emily

46 Charles Golding Constable (1821–79)

1835–6

Oil on board, 380 × 305mm (15 × 12")
The Britten-Pears Foundation
(R.35.40)

Charles Golding Constable was fascinated by ships and the sea from an early age. On 24 May 1826, Constable described the children at seven in the morning to Maria, who was staying in Putney: 'Charley was kneeling up in his bed which was full of things – chiefly boats'.[1]

Nine years later, Charles Golding had resolved to become a seaman, much to his widowed father's dismay. He was entered at fourteen as a midshipman on an East Indiaman, the *Buckinghamshire*. He described the necessary 'outfit' with which the household had been long astir: 'trousers, jackets &c by dozens – blue and white shirts by scores'. Then he continued, 'poor dear boy – I try to joke but my heart is broken. He is mistaken by all but you & me – he is full of sentiment & poetry & determination & integrity, & no vice that I know of.'[2]

Charles Golding sailed with the *Buckinghamshire* in mid August 1835, before which point it seems that his father had begun, and perhaps completed, this portrait. The youth sits dreaming, a book in front of him and a turbulent sea behind. The sea is worryingly stormy, but then Constable when he painted it was full of unease. On 12 September, he wrote to his friend George Constable (no relation):

> I have had as you may suppose a most anxious and busy time with Charles. I have done all for the best, and I regret all that I have done when I consider that it was to bereave me of this delightfully clever boy, who would have shone in my own profession, and who is doomed to be driven about on the ruthless sea. It is a sad and melancholy life, but he seems made for a sailor.

'In the midst of all my perplexities', he continued, 'I have made a good portrait'.[3] It is, almost certainly, this one – and probably the last Constable ever painted. Charles Golding, the most vigorous and independent of Constable's sons, joined the Indian Navy, in which he was eventually promoted to commander, and settled in Bombay (Mumbai). He was the only one of the seven children to marry and have children of his own. His gifts as an artist – fondly noted by his father – found expression in drawing charts of the Persian Gulf. Charles Golding died in 1879.

1 JCC II 1964, p.431 (Constable's journal, 24 May 1826).
2 JCC III 1965, p.129 (letter to C.R. Leslie, August 1835).
3 JCC V 1967, p.27.

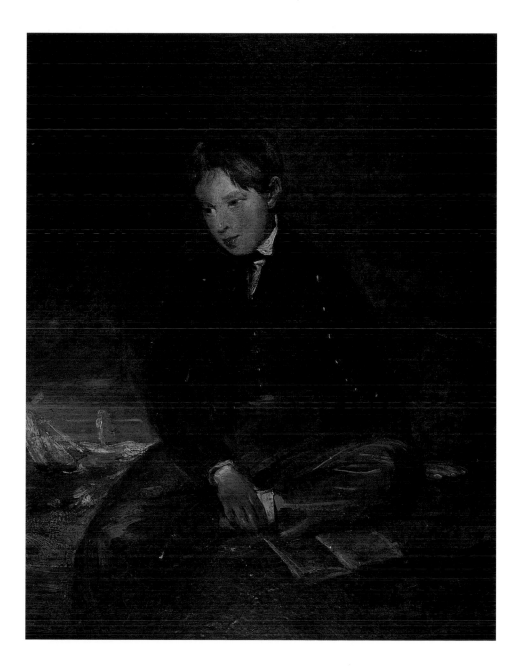

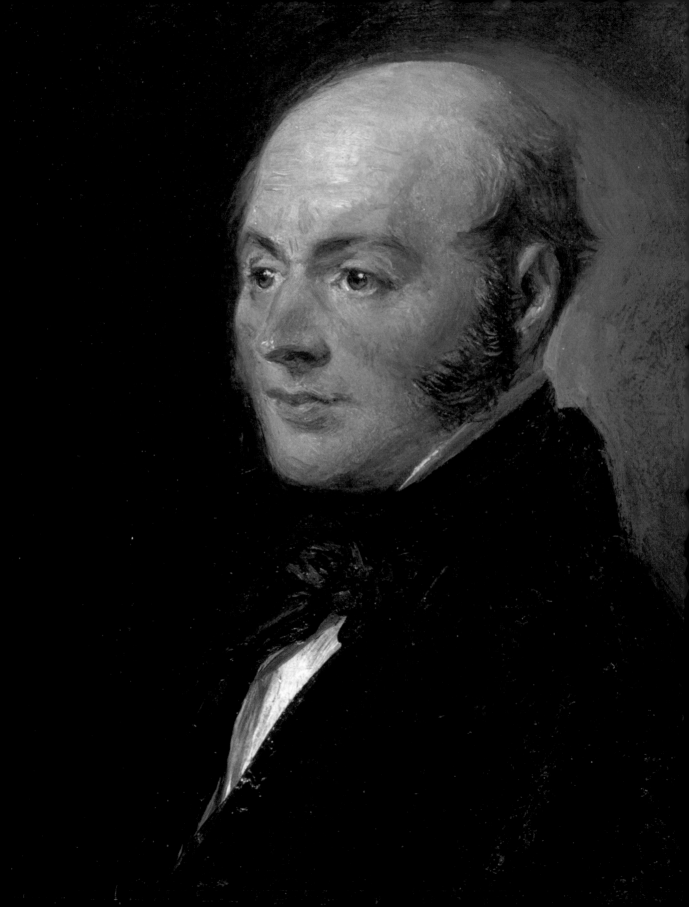

Constable in Later Life

47 John Constable (1776–1837)

CHARLES ROBERT LESLIE

*c.*1830

Oil on panel, 182 × 137mm (7⅛ × 5⅜")
Royal Academy of Arts, London

There is a gap of over twenty years in surviving images of Constable. When he reappears, the handsome and romantic figure so appealing to the young ladies of East Bergholt – and elsewhere – has become distinctly middle-aged. His hair has gone from the crown of his head. These two portraits by different artists seem to show him at roughly the same point in his life, and indeed in rather similar dress.

The younger painter, Charles Robert Leslie, was one of Constable's closest friends – in many ways replacing John Fisher who died in 1832. Leslie's *Memoirs of the Life of John Constable* is one of the most eloquent and touching biographies ever written of an artist. A mezzotint engraving by David Lucas of this portrait was the frontispiece to the first edition of 1843.

p.150: plate 47 (detail)

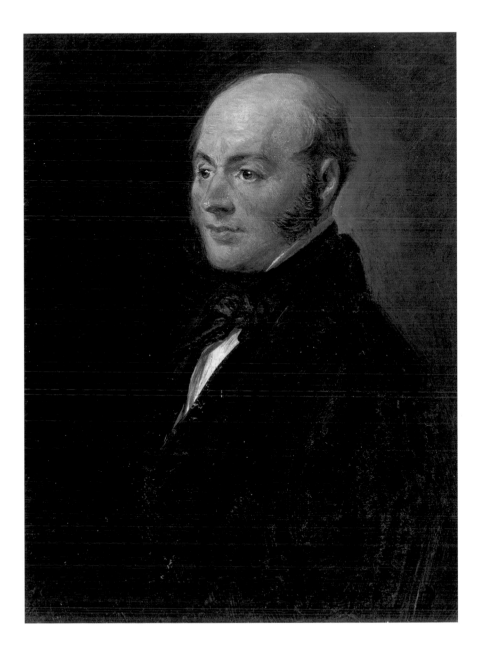

48 John Constable

DANIEL MACLISE

1831

Pencil on paper, 149 × 114mm (5⅞ × 4½")
National Portrait Gallery, London (NPG 1458)

Daniel Maclise (1806–70) was present in January 1831, when Constable – who had been elected a Royal Academician in 1829 – served as 'Visitor' in the RA Life School. This involved setting the models' poses and supervising the students' work. 'The little sketch', Maclise wrote to Leslie, 'was made under the disadvantage of my being in the upper and back seat, looking down on him as he sat on the front and lower one.'[1]

Constable is seen at work, but smartly dressed, as he would not have been in his painting room at home. He posed one of his models as Eve, on 3 January, and Constable wrote to Leslie, 'It is exceedingly liked … she makes a most delightfull [sic] Eve, and I have put her in Paradise (leaving out Adam). I have dressed up a bower, of laurels and put in *her hand* the *forbidden fruit*.'[2]

The foliage of this Eden was mistaken by some, Constable added, for Christmas holly and mistletoe, but he liked the landscape nude so much he painted it himself and Maclise drew him as he was doing so. Unfortunately, Constable's daughter Isabel found the result indecent and destroyed all but the head (R.31.20).

1 Leslie 1951, p.263.
2 JCC III 1965, pp.35–6 (letter to C.R. Leslie, 4 January 1832).

Select Bibliography and Further Reading

Items cited in capitals are abbreviated
references given in this book

ASLESON AND BENNETT 2001:
R. Asleson and S.M. Bennett, *British
Paintings at the Huntington* (New Haven
and London, 2001)

BAILEY 2006: A. Bailey, *John Constable:
A Kingdom of his Own* (London, 2006)

R.B. Beckett, 'Constable and Hogarth',
The Art Quarterly, vol.XXIX, no.2, 1966,
pp.107–10

Constable: Impressions of Land, Sea and Sky,
with contributions by J. Gage, A. Gray,
M. Evans and C. Shields (exh. cat.,
National Gallery of Australia, Canberra,
and Museum of New Zealand Te Papa
Tongarewa, Wellington, 2006)

CORMACK 1986: M. Cormack, *Constable*
(Oxford, 1986)

FARINGTON, *Diary*: J. Farington, *The
Diaries of Joseph Farington (1793–1821)*,
17 vols: vols 1–6 eds, K. Garlick and
A. Macintyre; vols 7–16, ed. K. Cave; vol.17
and index, ed. E. Newby (New Haven and
London, 1978–98)

FDC 1975: *John Constable, Further
Documents and Correspondence*, eds L. Parris,
C. Shields and I. Fleming-Williams (Suffolk
Records Society XVIII, Ipswich, 1975)

FEAVER 2003: W. Feaver, *Lucian Freud on
John Constable* (The British Council, 2003)

D. Foskett, *John Harden of Brathay Hall
1772–1847* (Kendal, 1974)

Foster and Sons, London, *A Catalogue
of the Valuable Finished Works, Studies
and Sketches, of John Constable, Esq. R.A.,
Deceased … Which Will be Sold by Auction by
Messrs. Foster and Sons … on Tuesday
the 15th of May 1838, and following Day*
(London, 1838)

HEBRON et al. 2006: *The Solitude of
Mountains: Constable and the Lake District*,
with contributions from S. Hebron,
C. Shields and T. Wilcox (exh. cat.,
Wordsworth Trust, Grasmere, 2006)

R. Hoozee, *L'opera completa di Constable*
(Milan, 1979)

IVY 1991: J. Ivy, *Constable and the Critics
1802–1837* (Suffolk Records Society,
Woodbridge, 1991)

JCC I 1962: *John Constable's Correspondence
I*, ed. R.B. Beckett (Suffolk Records Society
IV, Ipswich, 1962)

JCC II 1964: *John Constable's Correspondence
II*, ed. R.B. Beckett (Suffolk Records Society
VI, Ipswich, 1964)

JCC III 1965: *John Constable's Correspondence
III*, ed. R.B. Beckett (Suffolk Records Society
VIII, Ipswich, 1965)

JCC IV 1966: *John Constable's Correspondence
IV: Patrons, Dealers and Fellow Artists*, ed.
R.B. Beckett (Suffolk Records Society X,
Ipswich, 1966)

JCC V 1967: *John Constable's Correspondence
V: Various Friends, with Charles Boner and
the Artist's Children*, ed. R.B. Beckett
(Suffolk Records Society XI, Ipswich, 1967)

JCC VI 1968: *John Constable's Correspondence
VI: The Fishers*, ed. R.B. Beckett (Suffolk
Records Society XII, Ipswich, 1968)

John Constable's Discourses, ed. R.B. Beckett
(Suffolk Records Society XIV, Ipswich,
1970)

KITSON 1991: M. Kitson, 'A Context for
Constable's Naturalism', *From Gainsborough
to Constable* (exh. cat., Gainsborough's
House, Sudbury & Leger Galleries,
London, 1991), pp.9–13

C.R. Leslie, *Memoirs of the Life of John
Constable, Esq. R.A., Composed Chiefly
of His Letters* (London, 1843)

C.R. Leslie, *Memoirs of the Life of John
Constable, Esq. R.A., Composed Chiefly
of His Letters* (London, 1845)

LESLIE 1860: C.R. Leslie, *Autobiographical
Recollections*, 2 vols, ed. Tom Taylor
(London, 1860)

LESLIE 1951: C.R. Leslie, *Memoirs of the
Life of John Constable* [1845], ed. Jonathan
Mayne (London, 1951)

H. Lloyd, *The Quaker Lloyds in the
Industrial Revolution* (London, 1975)

E.V. Lucas (ed.), *Charles Lamb and the
Lloyds* (London, 1898)

D.S. MacColl, 'Constable as a Portrait-
Painter', *Burlington Magazine*, vol.XX,
no.107, February 1912, pp.267–73

F.G. Notehelfer, 'Constable and the
"Woodbridge Wits"', *Burlington Magazine*,
vol.CXLI, no.1158, September 1999,
pp.531–6

PARIS 2002: *Constable: le Choix de Lucian
Freud*, with contributions by W. Feaver, J.
Gage, A. Lyles, O. Meslay, L. Whitely and
R. Ur (exh. cat., Grand Palais, Paris, 2002)

PARRIS 1981: L. Parris, *The Tate Gallery
Constable Collection* (Tate Gallery, London,
1981)

L. Parris, I. Fleming-Williams and
C. Shields, *Constable: Paintings, Watercolours
& Drawings* (Tate Gallery, London, 1976)

L. Parris, I. Fleming-Williams and S. Cove,
Constable (Tate Gallery, London, 1991)

POINTON 1993: M. Pointon, *Hanging the
Head: Portraiture and Social Formation in
Eighteenth-Century England* (New Haven
and London, 1993)

G. Reynolds, *Constable: the Natural Painter* (London and New York, 1965)

REYNOLDS 1984: G. Reynolds, *The Later Paintings and Drawings of John Constable*, 2 vols (New Haven and London, 1984)

REYNOLDS 1996: G. Reynolds, *The Early Paintings and Drawings of John Constable*, 2 vols (New Haven and London, 1996)

RHYNE 1988: C. Rhyne, catalogue entries in *John Constable, RA (1776–1837)* (Salander O'Reilly Galleries, Inc., New York, 1988)

C. Rhyne, *John Constable: Toward a Complete Chronology* (Portland, Oregon, 1990) www.reed.edu/crhyne/papers/jc_procedure.pdf

M. Rosenthal, *Constable: the Painter and his Landscape* (New Haven and London, 1983)

M. Rosenthal, *Constable* (London, 1987)

SHAWE-TAYLOR 1990: D. Shawe-Taylor, *The Georgians: Eighteenth-Century Portraiture & Society* (London, 1990)

A. Shirley, 'Constable as a Portrait Painter', *Burlington Magazine*, vol.LXX, no.411, June 1937, pp.267–73

A. Shirley, 'Introduction to C.R. Leslie', *Memoirs of the Life of John Constable* (London Medici Society, 1937); see especially the list of Constable's portraits on pp.lxxviii–lxxxxii

SOLKIN (ed.) 2001: D. Solkin (ed.), *Art on the Line: the Royal Academy Exhibitions at Somerset House 1780–1836* (New Haven and London, 2001)

STRONG et al. 1991: R. Strong et al., *The British Portrait 1660–1960*, with an introduction by R. Strong and contributions from B. Allen, R. Charlton-Jones, K. McKonkey, C. Newall, M. Postle, F. Spalding and J. Wilson (Woodbridge, 1991)

TATE 2006: *Constable: The Great Landscapes*, with contributions from S. Cove, J. Gage, F. Kelly, A. Lyles and C. Rhyne (exh. cat., National Gallery of Art, Washington, and Huntington Art Gallery, San Marino, 2006)

B. Taylor, *Constable: Paintings, Drawings and Watercolours* (London, 1973)

R. Walker, *Regency Portraits* (National Portrait Gallery, London, 1985)

P. Winby, 'Constable and Admiral Western', *The British Art Journal*, vol.V, no.1, spring/summer 2004, pp.77–9

Picture Credits

Every effort has been made to contact the holders of copyright material and any omissions will be corrected in future editions if the publisher is notified in writing. Locations and lenders are given in the captions, and further acknowledgements are given below.

p.2 (detail) & plate 9: Reproduced by permission of the Wallop Family. Photograph Jeremy Whitaker; pp.8 (detail), 43, 64 (detail) & plates 4, 6, 7, 8, 13: Colchester and Ipswich Museum Service; pp.11, 58 (detail) & plates 1, 48: © National Portrait Gallery, London; pp.17, 26: © Christie's Images Limited; pp.20, 44, 108 (detail), 134 (detail) & plates 2, 3, 25, 26, 27, 38: © Tate, London 2009; p.22: Private Collection. Photograph Courtesy Michael Tollemache Fine Art, London; p. 27: © Bonhams, London, UK/The Bridgeman Art Library; p.28: Image courtesy of Cyril and Shirley Fry; p.30 (left): © The National Gallery of Scotland; p.30 (right): © Lucian Freud; p.32 (detail) & plate 14: © Crown copyright: UK Government Art Collection; p.36: Courtesy St James's Church, Nayland; p.38: Private Collection; p.40 & plates 5, 10, 40, 41, 42: © V&A Images/Victoria and Albert Museum, London; p.46: Courtesy of Sotheby's Picture Library; pp.53, 82 (detail) & plates 15, 17, 19, 20: © The Trustees of the British Museum; plates 11, 18, 45: Courtauld Institute of Art Gallery, London; plate 16: © Birmingham Museums & Art Gallery; plates 21, 28: Philadelphia Museum of Art: John G.

Johnson Collection 1917; plate 22: Private Collection, Ireland. Photograph Ewan Harkness; plate 23: Trustees of the Weston Park Foundation/Bridgeman Art Library; plates 24, 31: Photographs Richard Caspole, Yale Center for British Art; plates 29, 30: © The Fitzwilliam Museum, Cambridge; p.120 (detail) & plate 32: photograph: © 1999 The Metropolitan Museum of Art; plate 33: Photograph © 2009 Museum of Fine Arts, Boston; plate 34: Courtesy of Barnsley Metropolitan Borough Council Museum Service, Cannon Hall Museum Collection; plate 35: Museum of Art, Rhode Island School of Design, Corporate Membership Fund. Photograph Erik Gould; plate 37: Private Collection. Photograph Jonathan Farmer; plate 43: Private Collection, Paris. Photograph Beatrice Hatala; plate 46: The Britten-Pears Foundation. Photograph © Nigel Luckhurst; p.150 (detail) and plate 47: © Royal Academy of Arts, London.

NOTES

The forms of titles of works by John Constable follow those given in the catalogue raisonné of Constable's work compiled by Graham Reynolds in 1984 and 1996 (see Select Bibliography); an 'R' number indicates the listing of the work within this. Inscriptions are generally given only if in the artist's hand. The notes to the plates are written by Martin Gayford.

List of Lenders

Barnsley MBC Museum Service,
 Cannon Hall Museum, 34
Birmingham Museums & Art Gallery,
 16
British Museum, London, 15, 17, 19, 20
Britten-Pears Foundation, 46
Colchester and Ipswich Museum
 Service, 4, 6, 7, 8, 13
Courtauld Gallery, London, 11, 18, 45
Fitzwilliam Museum, Cambridge, 29, 30

Government Art Collection, 14
Metropolitan Museum of Art, 32
National Portrait Gallery, London, 1, 48
Philadelphia Museum of Art, 21, 28
Trustees of the Portsmouth Estates, 9
Private Collections, p.22, 12, 22, 33, 36,
 37, 39, 43, 44
Museum of Art, Rhode Island School
 of Design, 35
Royal Academy of Arts, London, 47

Tate, 2, 3, 25, 26, 27, 38
Victoria & Albert Museum, 5, 10,
 40, 41, 42
Weston Park Foundation, 23
Yale Center for British Art, 24, 31

At the time of going to print, the
following works will be exhibited at
the National Portrait Gallery, London,
only: plates 7, 36; and plate 6 at
Compton Verney, Warwickshire.

Acknowledgements

As with any project such as this, we have been greatly facilitated by the research and publications of other scholars in the field, and owe a particular debt to the catalogue of Constable's work compiled by Graham Reynolds and published by Yale University Press in 1984 and 1996. We are most grateful to Graham for his advice and encouragement in the early stages of the project. Similarly, we would like to extend our warmest thanks to Charles Rhyne, who has been extraordinarily generous in providing essential information on a number of portraits by Constable that he has examined over the years, especially examples in American collections. Charles had originally proposed an exhibition on the subject of Constable's portraits to the National Portrait Gallery in the late 1980s, then under the directorship of the late John Hayes, but this project faltered at that time for practical reasons. The interest and belief in Constable's portraits shown by the artist Lucian Freud over the years has been a catalyst throughout the genesis of this current exhibition.

From the very beginning, Sandy Nairne and his colleagues at the National Portrait Gallery have supported this project with encouraging enthusiasm. We would like to single out Sarah Tinsley, Sophie Clark and Jacob Simon for their helpful roles in steering the exhibition as well as for advice on this book, and also Susie Foster, Claudia Bloch and Linda Schofield for their attentive editing.

David Moore-Gwyn at Sotheby's and Michael Tollemache of Michael Tollemache Fine Art have offered invaluable assistance with loans from private collections. Michael has for many years been compiling information on Constable's portraits of members of the Dysart family, and we are most grateful to him for kindly allowing us access to his files. Stephen Lloyd of the Scottish National Portrait Gallery has also offered generous help with information on his ancestors the Lloyds of Birmingham, a number of whom Constable painted around 1806. At many points Josephine Gayford assisted with advice, encouragement and, more practically, transportation.

We would also like to single out the following people for their assistance in various ways: Tony and Margot Bailey, Freda Constable, John Constable, Richard and Valerie Constable, Sarah Cove, David Dawson, Mark Evans, William Feaver, Brendan Flynn, Jonathan Fry, Cyril and Shirley Fry, John Gage, Anna Gray, Rachel Hewitt, Tom Hodgson, Frederick Ilchman, Ed Kanfer, Clementine Kerr, Catherine Kinley, Lowell Libson, Carina Lowe, Susan Morris, Jane Munro, Martin Postle, Andrea Rose, Richard Rusbridger, Joanna Selborne, George Shackelford, Joseph Sharples, Kim Sloan, Peter Smith, Guilland Sutherland, Jennifer Thompson, Helen Valentine, Aurelie Vandevoorde-Maury, David Wardlaw, Ian Warrell and Gareth Williams.

MARTIN GAYFORD AND ANNE LYLES

Index

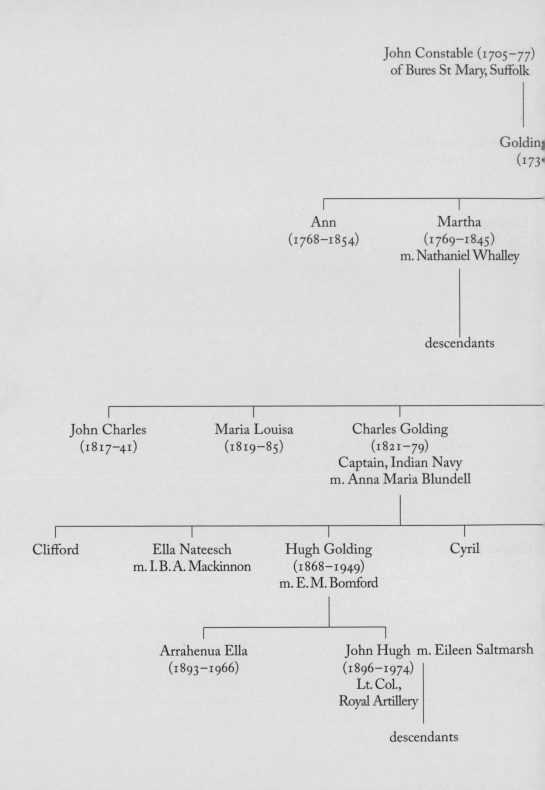

John Constable (1705–77)
of Bures St Mary, Suffolk

Goldin
(173

Ann
(1768–1854)

Martha
(1769–1845)
m. Nathaniel Whalley

descendants

John Charles
(1817–41)

Maria Louisa
(1819–85)

Charles Golding
(1821–79)
Captain, Indian Navy
m. Anna Maria Blundell

Clifford

Ella Nateesch
m. I. B. A. Mackinnon

Hugh Golding
(1868–1949)
m. E. M. Bomford

Cyril

Arrahenua Ella
(1893–1966)

John Hugh m. Eileen Saltmarsh
(1896–1974)
Lt. Col.,
Royal Artillery

descendants